WHALLEY & AROUND

THROUGH TIME

Roger Frost
& Ian Thompson

AMBERLEY PUBLISHING

First published 2011

Amberley Publishing
The Hill, Stroud
Gloucestershire, GL5 4EP

www.amberley-books.com

Copyright © Roger Frost & Ian Thompson, 2011

The right of Roger Frost & Ian Thompson to be
identified as the Authors of this work has been
asserted in accordance with the Copyrights, Designs
and Patents Act 1988.

ISBN 978 1 84868 282 5

British Library Cataloguing in Publication Data.
A catalogue record for this book is available from
the British Library.

Typeset in 9.5pt on 12pt Celeste.

Typesetting by Amberley Publishing.
Printed in the UK.

Introduction

This book is intended to be a pictorial and heritage guide to the communities around three significant rivers in the North-West of England. The rivers are the Lancashire Calder, the Ribble and the Hodder, all of which have their origins in Yorkshire but flow to the west rather than the east.

The rivers come together to the west of Whalley. First, the Hodder joins the Ribble, just below ancient Great Mitton, and then, less than a mile away, the Calder makes a similar confluence with the Ribble close to Hacking Hall. The Ribble then makes its way, via Roman Ribchester, to Salmesbury and on to Preston beyond where it joins the sea.

The valleys of the three rivers contain some of the most beautiful countryside and some of the most historic villages in England. Neither of these are as widely known, or as visited, as they might be but to those 'in the know' these rural and picturesque valleys are places to which they return time and again. Some are fortunate to be able to live in the three valleys, working in the nearby cities and towns of the area – Preston, Blackburn and Burnley – to which access is easy and from which the journey home to the quiet of the countryside is welcomed rather than endured as it is elsewhere in England.

At the centre of the three valleys is the village of Whalley. With its ancient parish church and its Cistercian Abbey it was once the ecclesiastical capital of the area. St Mary and All Saints, Whalley, was not only the parish church to the village but it was also the parish church to a huge area of north-east Lancashire, an area which included Burnley, Accrington, Great Marsden (now

Nelson), Colne and a host of villages and townships especially in the Calder and Ribble valleys.

The parish of Whalley was the largest in England and its church, founded at the end of the sixth century, was, in effect, the Minster church for the whole area. The parish church predated the Abbey by almost 700 years but, when the Abbey arrived from the Wirral, in 1296, the two great institutions were effectively unified into one powerful body that had a role in most aspects of local life. It was the Abbey's involvement in the Pilgrimage of Grace of 1536, the most dangerous of the rebellions against Henry VIII, which caused the abbey to be dissolved.

The parish church survived retaining its important ecclesiastical role for a further 200 years and Whalley village continued to have an influence much greater than its size might otherwise have allowed. A visit to St Mary's and All Saints, with its numerous memorials to the many families, which looked to Whalley church for local leadership, confirms this but the world was soon to change and the valleys of the Calder, Ribble and Hodder were to be involved in that change.

In the seventeenth century, Whalley and the surrounding area was involved in the English Civil War, and it was a battle in the village, and another nearby in Read, that determined the outcome of the conflict in favour of Parliament in Lancashire. Earlier in the century parts of the Calder valley had witnessed the events that lead to the famous Lancashire Witch Trials, which took place 200 years ago in 1612.

In the eighteenth century the biggest changes yet were to take place. These were not political changes or changes in the Church; they were fundamental changes in how people lived their lives. Until this time, there being no substantial market in the area, the economies of the valleys of the Calder, Ribble and Hodder were based on subsistence farming.

All this changed with the advent of the Industrial Revolution. With improved transport, markets expanded and industries that had once been local found that they had regional, national and even international demand. Men, women and children who had worked at home found themselves increasingly working in a new factory or in a much larger mine.

Factories, mainly textile mills, did not come to the three

valleys in equal measure. One of the valleys, that of the Calder, which contained the largest of the coal deposits, became an industrial powerhouse the like of which had not been seen in these parts before. Places, like Burnley and Colne, hitherto small and insignificant villages, became considerable towns changing the landscape of the Lancashire Calder for ever.

It was the valley of the upper Calder, together with the valleys of its larger tributaries, which changed the most. The ancient parks, woodlands and meadows of the river valley ceased to be the home of the small farmer and the handloom weaver becoming, instead, industrial towns with thousands of mill workers living in tiny terrace houses crammed up against large factory walls. The sounds of cattle grazing and birds singing were replaced by the factory bell and the sound of the locomotive as it made its heavy way from station to goods yard.

In the early days it was water that powered the mills, something that all three valleys, given their rainfall, had in abundance. In fact, all of them once had their mills. Water-powered mills were not new – almost every township had at least one mill. In Whalley there were two and another close by. They had been used, for centuries, to grind locally grown corn into flour for bread. In this area, oats (which Dr Johnson said was only fit for horses) was made into a substitute for bread, havercake, a hard oat cake, which was eaten, not in preference to wheaten bread, but because oats were much easier to grow than wheat in this part of the world.

The coming of steam determined the future development of the valleys but the non-industrial areas – the lower Calder and the valleys of the Ribble and the Hodder had their industries. These included cotton mills in Whalley and Read, calico printing works and cotton in Sabden, and paperworks in Simonstone, but these did not come to dominate these landscapes as they did in the upper Calder.

It might have been supposed that the industrial upper Calder might have become divorced from the areas with which it had once shared a common past, but nothing is further than the truth. As the mill workers, iron moulders and mechanics of places like Burnley and Padiham began to win more time for themselves they made their way to the valleys of the Ribble and

the Hodder in search of the things their daily grind had caused them to lose in the towns and villages where they worked.

What they were searching for was the open air, the song birds loved by their ancestors and the silvery fish of the relatively clean Ribble and Hodder. These valleys still cater, in the same ways, for the workers of the largely industrial and neighbouring towns of the area and further afield.

This book visits the villages and communities of the rural valleys as they were 100 or so years ago and it also attempts to demonstrate what they are like today. Things have changed, of course, but a surprising amount has remained the same. It is as if these valleys have determined what they want to be. They do not want to advance with the rest of the modern world.

The reader will visit ancient villages and churches, remote inns, historic bridges and lonely but beautiful and tranquil places – all them with a story to tell, a message to deliver. The authors have known the three rivers, and their valleys, all their lives but only one of them has lived there – the other is a product of the upper Calder where he lives in a village famous for its cotton mill, but he has known the three valleys for the best part of fifty years. He, like the late Jessica Lofthouse, who you will meet in these pages, loves the three rivers equally and is never more at home than when he is exploring the Lancashire Calder, the Ribble and the Hodder.

Roger Frost

Ian Thompson

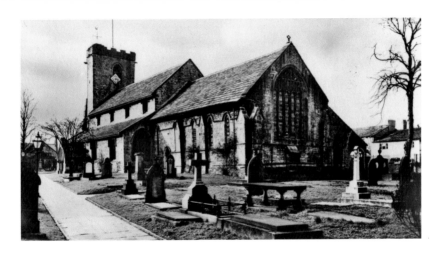

St Mary All Saints, Whalley

Whalley was once the 'ecclesiastical capital of north east Lancashire' so it is appropriate that any pictorial history of the village and the area around it should start with images of the parish church. St Mary and All Saints church rather than the famous Abbey? The answer has to be 'yes' because the parish church was here 700 years before the Cistercian monks decided to settle in the village. There was certainly a church in Whalley in the Dark Ages. At the time of the Domesday Book (1086) the church was known as 'the White Church under the Hill', a succinct description not only of the early church building but its location under Whalley Nab. The Parish of Whalley was once the largest in area in England stretching from the Ribble Valley to the Yorkshire border. It included a considerable number of chapelries and townships, such as Read, Simonstone, Padiham, Clitheroe, Downham, Burnley, Briercliffe, Cliviger, Great and Little Marsden (present day Nelson and Brierfield), Colne, Accrington, Altham and Haslingden. The Vicar of Whalley had an immense area for which he was responsible and, for the most part, this remained the case until well into the nineteenth century.

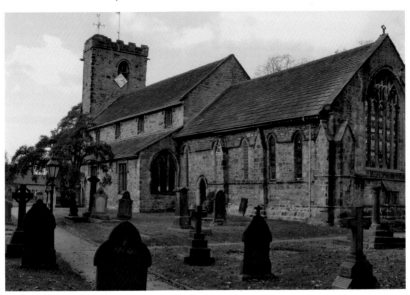

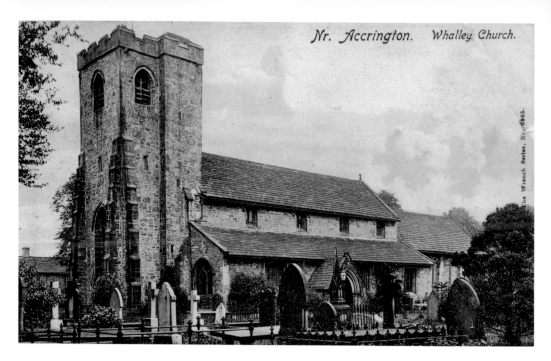

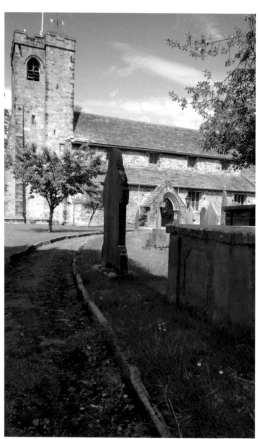

The Tower of the Parish Church

There is no evidence of a Saxon church, except perhaps the famous crosses in the churchyard, and there is almost nothing of the Norman church save the doorway into the church from the south porch. It is clear that the church was rebuilt in the Early English style and there are many references remaining to the building work of the thirteenth and early fourteenth centuries. In addition, there is quite a lot of later Perpendicular work, the most significant example being the tower itself. Many of the older Lancashire churches were either rebuilt or remodelled in the fifteenth century when the county enjoyed a period of considerable prosperity because of the opening up of the European wool market and the resulting rise in wool prices. When the foundations for the tower were being made in c. 1440 the workmen found large blocks of masonry at about four feet. It is supposed that these were the remains of a Roman building giving credence to the theory that there was a small Roman fortification on this site. In the foreground of the more recent photograph notice the gravestone of one John Wigglesworth, the landlord of the Whalley Arms, an inn in the village. We will be meeting him again in later in the book.

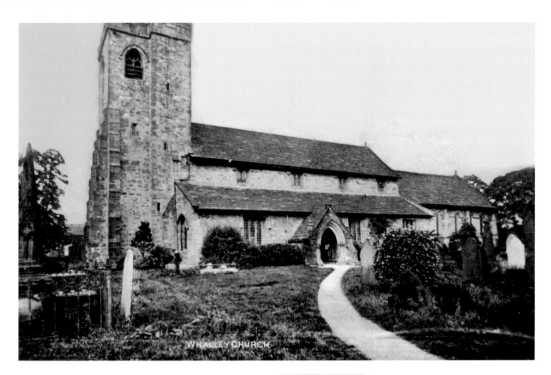

WHALLEY CHURCH

The South Porch, Whalley Parish Church
The porch itself dates only from 1844 but the doorway into the church contains Norman work which is often missed by the visitor. It is worthy of attention though it is now not complete. This Norman work reminds us of the reference in the Domesday Book to Whalley. That there was one at all is remarkable because north-east Lancashire, which had been settled centuries before, gets only a handful of mentions. It is possible that this was so because, in the 1070s, William I had put down, with great severity, a very serious revolt in the north of his kingdom. It is thought that the effect of this was that large parts of the North Country were laid to waste and that whole communities were destroyed. Those who carried out the King's instructions in compiling the great book made visits only to places which had recovered from the troubles only a decade before. These included Whalley, Pendleton and Huncoat which, in 1086, was spelled Hunnicot. Little is said of Whalley in the Domesday Book but it did indicate that 'St. Mary's church had two carucates of land exempt from all customary dues'.

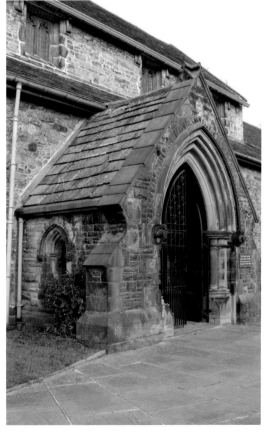

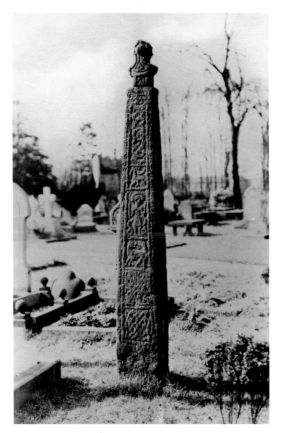

The Churchyard Crosses I

If any proof was required of the antiquity, or importance, of Whalley Church all one has to do is consider the three Anglo-Saxon Crosses in the churchyard. The crosses were already there when the monks arrived at the end of the thirteenth century and they attributed them to the very earliest days of the church which, had they been right, would have given them a date of *c.* 597. Others have speculated that they predate the church and were preaching crosses used by St Paulinus, the first bishop of York. They probably date, however, to the tenth and eleventh centuries but they were hardly venerated by the seventeenth when, during a riot, a mob overturned the crosses and threw them into a ditch. Shortly after they were used as fence posts and two of them still bear the marks of this abuse. The crosses were recognised for what they were by William Johnson, who was Vicar of Whalley from 1738 to 1776. He had them restored and firmly fastened into what are believed to be their original bases. It is understandable that the crosses remain in the churchyard. It is their rightful place and being where they are they remind us of their original purpose but perhaps they should be given some protection from the elements. They have done well to survive as well as they have for almost 1,000 years.

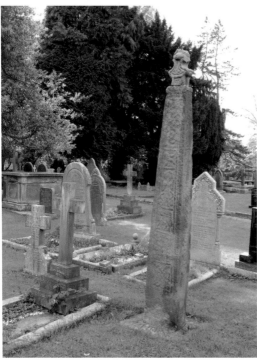

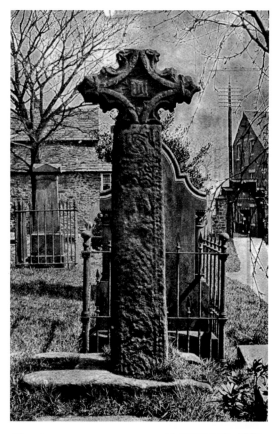

The Churchyard Crosses II

One of Johnson's successors was the great historian Dr Thomas Dunham Whitaker. A local man from Holme-in-Cliviger, near Burnley, Dr Whitaker was very proud of the crosses in his churchyard at Whalley. He was a friend and contemporary of the great art expert and connoisseur Charles Towneley, who was also from Burnley. Towneley knew the young artist J. M. W. Turner who was to achieve fame as, perhaps, the greatest artist England has produced. Towneley, at Whitaker's request, commissioned Turner to visit Whalley to undertake work for the illustration of Whitaker's *History of the Original Parish of Whalley* and one of his studies is of the three Whalley Crosses. It is from this study, which was published in the *History*, that we have to turn for the detail that is necessary to describe the crosses. The book illustration was engraved by James Basire and the page also shows three of the miserichords which originally came from the Abbey church but are now to be found in the parish church.

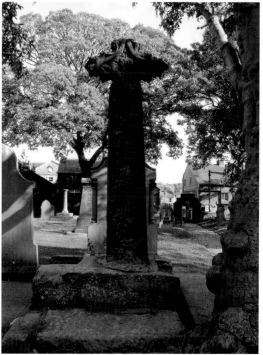

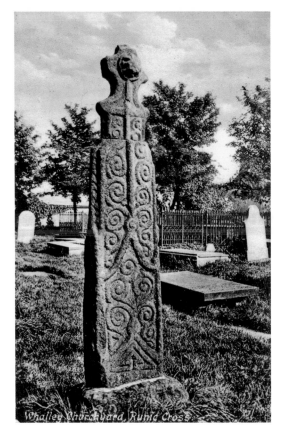

Whalley Churchyard, Runic Cross.

The Churchyard Crosses III

There is no mistaking the crosses as they are very different. We will consider them in the order they appear in this book. The first cross is to the most westerly. It is the oldest of the crosses and has the most varied decoration. At the top there is a dove symbolising the Holy Spirit. Below there is a halo figure thought to be Our Lord and in another panel is the Scandinavian emblem of the 'Dog of Berser', a reference to eternity and taken over in Christian Art to represent the Creator. The cross shaft near the chancel door is also tenth century. Unfortunately, the carving is almost obliterated though it is thought to be of the Annunciation. The small cross that surmounts the shaft is fourteenth century and is reminiscent of a cross hear that Dr Whitaker had taken to Holme-in-Cliviger and which remains there. The third cross is the most well known and it is likely that it is the youngest being made in the eleventh century. It represents the Tree of Calvary and is the best preserved. However, the cross was originally considerably taller as part of the shaft is missing. Also the arms of the cross are absent and the head is damaged.

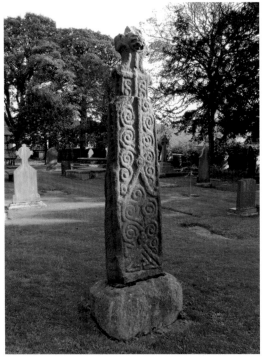

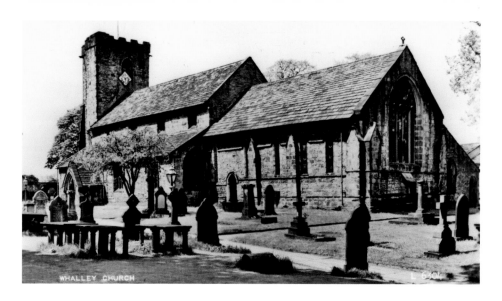

WHALLEY CHURCH

L 6304

The Sundial in Whalley Churchyard

The fourth monument in the churchyard is the sundial, which, at first sight, appears to have been constructed all at the same time. In fact the date, of 1757, shown on the sundial, refers to a repair of that year to the pillar. The dial itself dates from 1737 and the steps from 1773. Country churchyards, like this one, often had sun dials before the making of cheaper and more reliable clocks were available. Often they were built into the fabric of the church like the well known one at St Peter's in Burnley. Of course the problem was to find a sunny place within the precincts of the church which would make it possible for the dial to be of use. However, in the days when keeping the correct time was not as important as it is now it did not really matter that the sun was hidden behind clouds or that trees shaded out the sun. The dial is, therefore, a very pleasing reminder of gentler days.

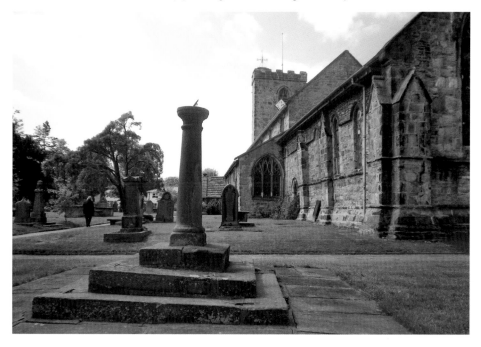

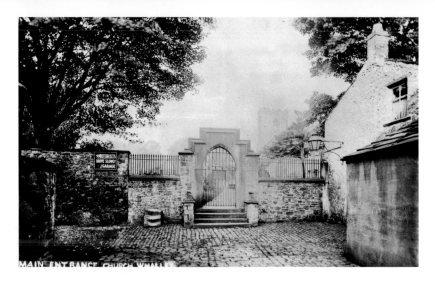

MAIN ENTRANCE CHURCH WHALLEY

The Parish Church: the View from the Village

These pictures serve to remind us that the purpose of St Mary and All Saints was to serve the people of Whalley and its vast parish. Here we see the church looking to the west from the boundary wall and its arched gateway in the oldest part of the village. In the past this wall separated the church and God's acre (the graveyard) from the village. It was a necessary division not least because the simple folk of Whalley had much respect, even fear of the grave yard especially in the dark of night when the powers of the Almighty might appear to be in the wane. Either side of the wall the people of the early village lead their day-to-day lives whether they were bakers, inn keepers, weavers, blacksmiths or whatever they were but they all needed access to the church at the important times in their lives and this is the most direct and picturesque of the routes into Whalley Church.

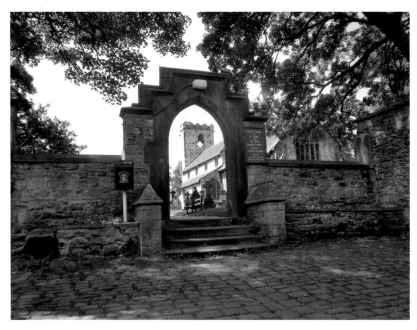

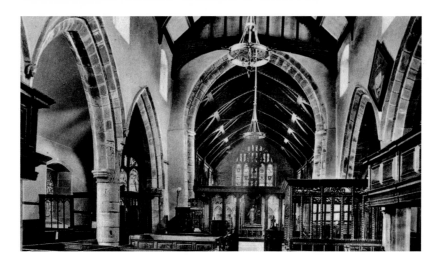

Whalley Parish Church: the Interior I

If there is plenty to interest the visitor about the church building and the graveyard, there is much more inside St Mary and All Saints. Here we have the space only to look at the most interesting features and the great east window with its magnificent heraldic shields, which were inserted in 1816 during the time of Dr Whitaker, is first among them. If proof was needed of the importance of Whalley Church in the past, here it is before you. The shields are in five rows depicting shields representing either families or great offices of the church that are associated with the original parish of Whalley. The Archbishops of Canterbury, who had the right of presentation from the Reformation, are represented, in the top row, by the arms of Charles Manners Sutton who was Archbishop from 1805 to 1828. Also at the top are the arms of the Abbey of Whalley, Henry de Lacy, Earl of Lincoln (and Lord of Blackburnshire) in the Middle Ages, the Duchess of Buccleugh (representative of the Lordship at a later time) and the Curzon's of Whalley Abbey. In the second row you will find the arms of Towneley of Towneley (Burnley), a family we will be meeting again. The church also contains a fifteenth-century chancel screen and several monuments one of which is believed to be to Peter de Cestria who was incumbent from 1235 to 1295. Another is to Dr T. D. Whitaker, the historian, who was Vicar of Whalley from 1809 to 1822.

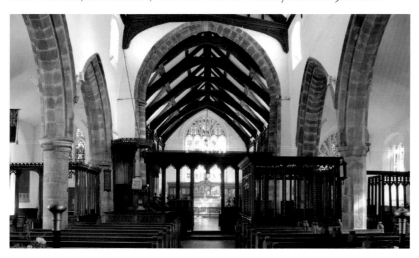

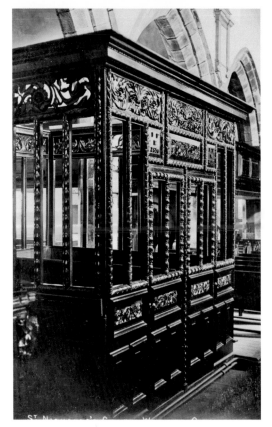

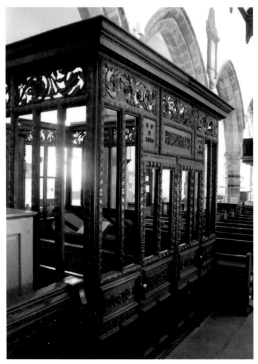

Whalley Parish Church: the Interior II

These photographs are illustrative of the Kage, a family pew of the Nowell's of Read that dates from 1534. To be precise the Kage (which can also be given as Cage) is the equivalent of a small chapel enclosed by screens. Though there is another similar feature in the church this is a rare survivor in itself. The Nowell Kage recalls a most distinguished local family. Alexander Nowell became Dean of St Paul's in London. One of the greatest of Elizabethan divines he is also remembered at the inventor of bottled beer! A close relative, Roger Nowell, was responsible for one of two inscriptions on the Kage which can still be seen. His are the initials, R. N. R., were placed on the Kage in 1610 two years before he became, as a local magistrate, involved in the famous Lancashire Witch Trial. Situated outside the chancel is the remaining part of the Medieval Pew which was placed in the church in the fifteenth century by Sir John Towneley in his right as Lord of the Manor of Hapton. It was this Sir John who rescued the wonderful medieval altar vestments from Whalley Abbey and which are now one of the great treasures of Towneley Hall in Burnley.

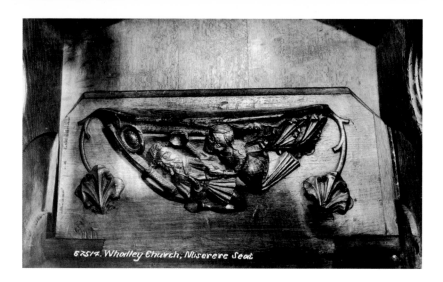

62514. Whalley Church, Miserere Seat.

Whalley Abbey Church: the Interior III

The choir stalls of Whalley Church are among the most interesting in the country. They came from Whalley Abbey after the Dissolution and it has been said that they constitute the churches most beautiful possession. A date of 1430 has been ascribed to them and they were made by the Abbey wood carver who was called Eatough. The stalls are not complete but visitors are invited to examine the misericords, the carved seats, which were used by the monks when they were in the great Abbey church. They served two purposes – obviously seats, but they could also be turned up and used for leaning on, particularly useful during the long services of the medieval church. When turned up they reveal the most interesting carvings as we illustrate here. This one is of a warrior being beaten by his wife who looks to be quite useful with a ladle. The one to find, however, is the one which depicts an attempt to shoe a goose. It is accompanied by the following words, 'Who so melles hy(m) of y al me(n) cu(m) heir and shoe ye ghos', which means that meddling in other people's affairs never succeeds. Note also the charming depiction of a blacksmith's workshop with its anvil, bellows and other tools.

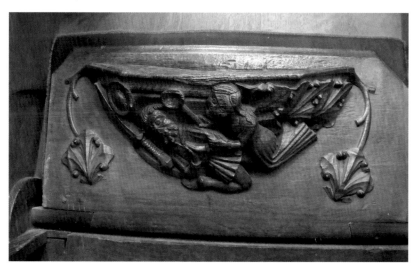

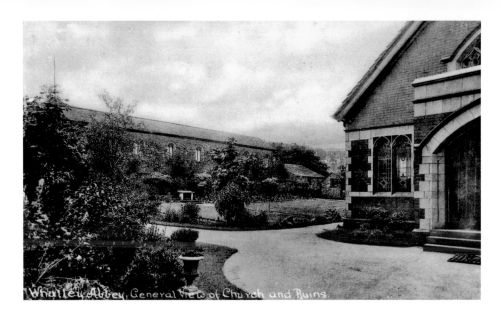

Whalley Abbey, General View of Church and Ruins.

English Martyrs Roman Catholic Church

It is only to be expected that such an important Christian site as Whalley should have its own Roman Catholic church. The building itself is dedicated to the English Martyrs, a reference to the Catholics, both men and women, who suffered for their faith during and after the Reformation when membership of the Old Church carried many penalties including execution. A number of residents of Whalley Parish can be included in a long list and the brothers John and Robert Nutter of Reedley Hallows, both of whom have been beatified, but who were executed in 1584 and 1600 respectively. The church is on the Sands, below the Abbey remains. It was opened in 1926 as a temporary building and is long and low with a red-tiled roof and mock timber framing. There is some early twentieth-century stained glass by Clarke of Brentwood and the nearby presbytery is an attractive eighteenth-century house.

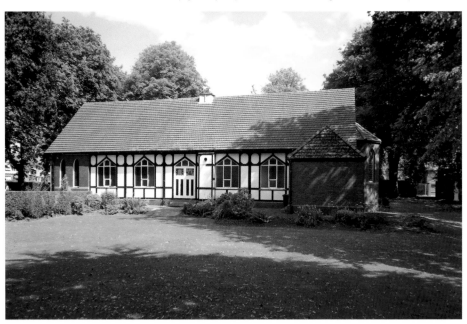

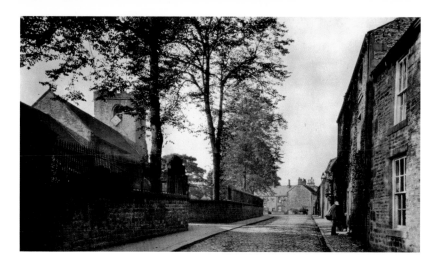

Church Lane, Whalley

Church Lane is likely to be the oldest street in Whalley, though one would suspect that Towngate, a name not now used, but referring to a road close by, could claim that honour. The lane was once part of the ancient Whalley to Ribchester road, which was bypassed by the coming of the turnpikes. In the past the lane contained the village well and the village cross. On the left is the De Lacy Arms (c. 1863), which was once the site of the ancient manor house of Whalley. In more recent times property behind the inn was used as the Charnel House where disinterred bones from the nearby graveyard were stored. Later the same building was used as the Bier House where the churches wooden bier, which carried the dead to their graves, was stored. The former cottages which were on the left were demolished just over 100 years ago but, on the right, the old cottages remain. One of them, as you enter the Lane, was the Blue Bell inn. Number 6 was originally two cottages made into one in 1806 when the upper rooms became the first Methodist Chapel in the village. Number 9 is interesting as it is the smallest house in Whalley. Further up the Lane is an old property, Poole End, which takes its name from the ancient fish ponds kept by the monks of the Abbey. On old maps the water courses here are marked as the Canals.

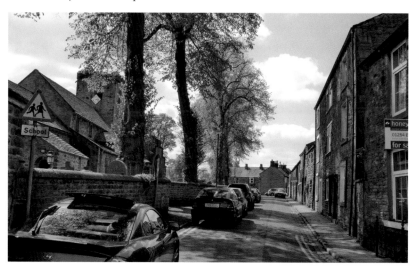

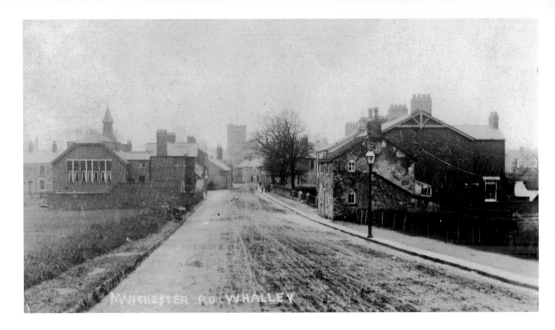

Accrington Road I

This road was once the main road out of Whalley via Portfield to Accrington and Burnley. It has been bypassed by a modern road but a significant reminder of the older road's importance can be seen in Whalley's last remaining Toll House, which dates from the early nineteenth century. In this modern picture the Toll House is the light-coloured building on the right. It was once a tearoom and coffee shop. Also on Accrington Road the former police station (late nineteenth century) can be found as can the former Assembly Rooms (the Sem's to locals) of 1890. This latter building became a private club. Just below the old Assembly Rooms is the present-day community centre, the venue for many village events.

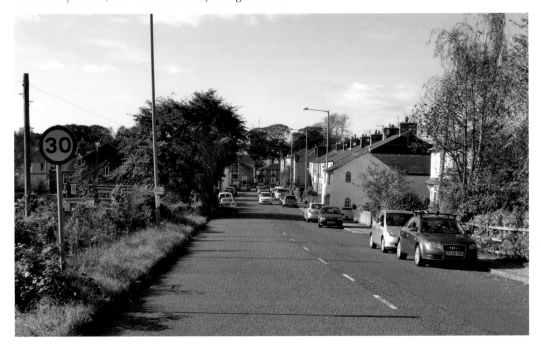

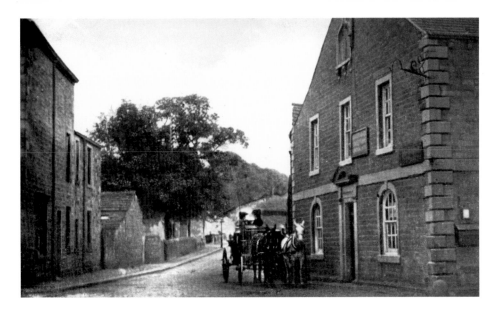

Accrington Road II

Few people in Whalley gave Accrington Road its proper name. To them it was Broken Brow or merely the Brow. It was beloved of cyclists because coming into the village the Brow was a long hill, steep in parts, which meant that it was not necessary to do much peddling for some distance. In the eighteenth century there was a bowling green behind the Whalley Arms which you can see to the right in the modern picture. Behind that was Bowling Green Field and on the left, but a little higher up were the quaintly named fields Lower and Higher Forty Shillings. Above them were Cunnery Wood and opposite was the Warren. They refer to the same thing, a rabbit warren and the first named comes from the Middle English 'coninger' which means rabbit warren. In the past rabbit meat was much more popular than it is today and most villages would have had a rabbit warren. Close by are two fields with similar names – Imps and Little Imps. These names refer to early nurseries for saplings and the word derives from Early English.

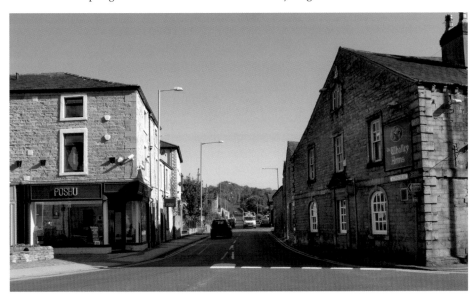

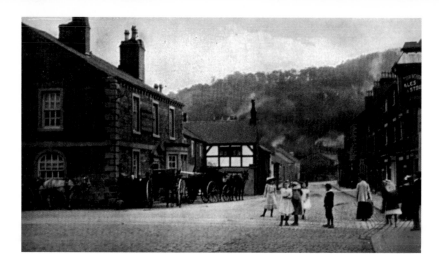

The Whalley Arms

The village has four remaining inns and, of these, the Whalley Arms is perhaps most interesting. The building is on King Street and it might be regarded as the prettiest non religious property in the village. The Whalley Arms, as Pevsner has it, sports a 'reused tripartite gable window with an ogee head, halfway in shape between the Yorkshire seventeenth century tradition and the Gothick of 1800'. The date on the building (1781), supports this, but looking at the structure, you might not realise that some of the stone from which it is constructed came from the Abbey. This is not uncommon in a place like Whalley but what makes the stone used for the Whalley Arms more interesting is that first it was taken from the Abbey to Portfield Hall, which was about a mile away, and when that building fell into ruin the stone was brought back to the village and the Whalley Arms was built from it. It is worth mentioning that Whalley's old Market Place was outside the inn, which became associated with the markets held there, so much so that, in the later years of the eighteenth century and the early ones of the nineteenth, the Whalley Arms was at the centre of the local timber industry as the big annual sales were held there. Remember John Wigglesworth, from a reference earlier in the book? He was principal innkeeper of the town and the great timber sales were in his inn, the Whalley Arms.

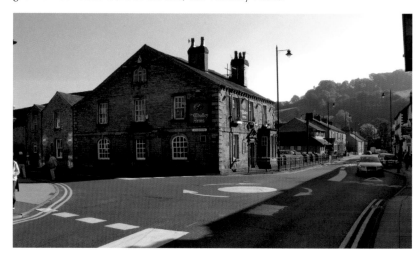

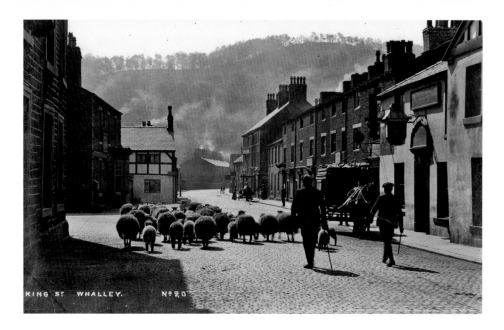

The Former Town Gate

These pictures are of Whalley's Town Gate, now King Street, and it was here that Whalley Markey was held. Town Gate is one of the oldest street names in England. It derives from the Old English word 'tun' and the Old Scandinavian word 'gata'. Tun means a fence, but later the word became associated with the buildings, mostly houses, nearby and it is from this that we get out word 'town'. Gata has nothing to do with the gate you might find in your garden wall. It is, in fact, another, and very early, word for a road or a path. So 'Town Gate' means the 'road in the middle of the settlement' or the 'road to the settlement'. In the more recent picture you can see part of the Swan, the Whalley Arms and the Dog each of which were originally farms with land stretching behind them. We will be considering many of the other buildings that can be seen in this picture.

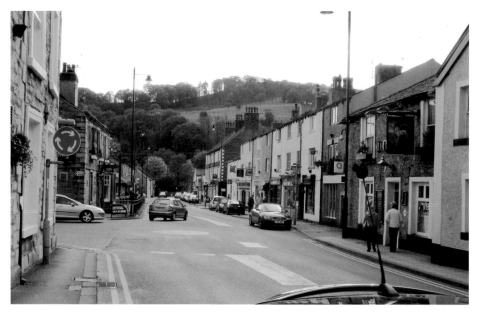

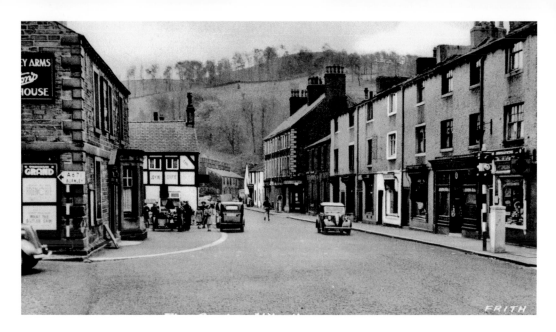

The Village Centre

King Street is Whalley's main street and here, in the sunlight of the newer picture you can see the Whalley Arms and the Swan Hotel. It is with the Swan that we are to concentrate this time. The building dates from 1780 and it is seven bays and three storeys with a projecting pedimented three bay centre though most of the windows and doors were changed in the nineteenth century. The Swan was a noted coaching inn and the coach; the 'Manchester Mail' made regular stops there. One source refers to the Swan Hotel as the meeting place of the Sisterly Love Society. On the left is a large row of eighteenth-century buildings, many of which have been converted into shops. We will look at them in the next picture.

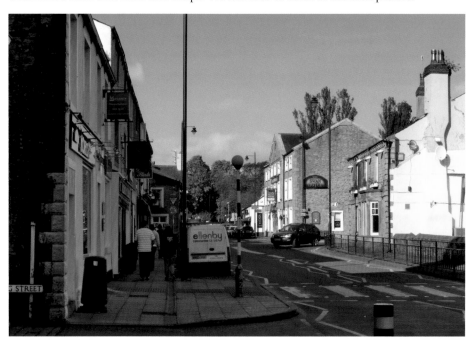

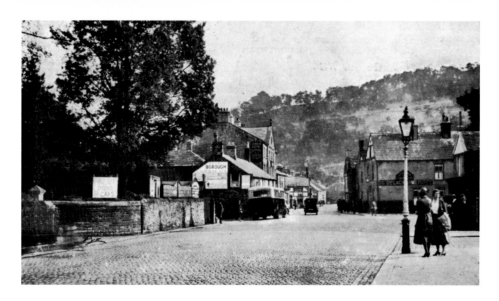

King Street I

Many people contend that Whalley has not changed very much in many years and most of them would like that to remain the case. There have, however, been a number of changes, some of which have been good but others have been less so. We would argue that the building of the bypass was a great improvement as it freed the village from much traffic, especially at holiday times. A smaller change has been wrought to property on the left of these photographs where land near Woodlands Drive has been made into a lovely village centre garden. A bus station and the facilities needed by the passengers who use it have also been provided and there has been much improvement to the buildings now occupied by Cosgroves. This should be set against the unchanging site of the de Lacy Arms which was once the most important building in the village. It was where the manorial courts were held and where the moots, or meetings, were held over one thousand years ago. Now the inn bears the name of the family a member of which lived there. Opposite, on the site of the wine shop was Whalley's rope walk.

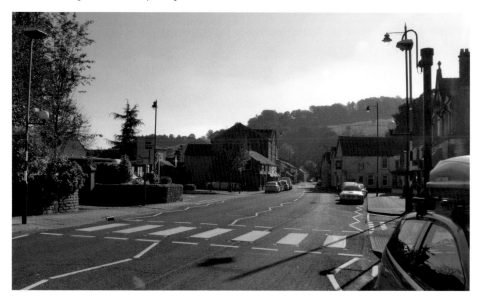

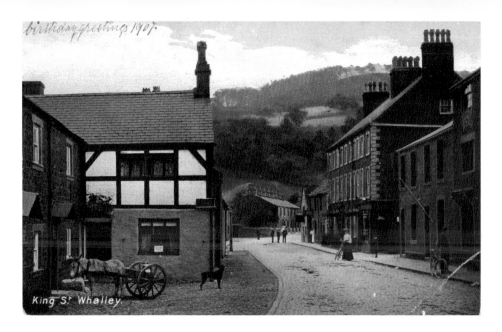

King Street II

It is not immediately apparent but Whalley's main street has many buildings from different eras. In fact it is more complicated than that because some relatively recent buildings occupy very old sites yet they appear to be antique. The general rule is that if property is at ninety degrees to King Street, with its gable end parallel to the street, it is either old, or it occupies an old, possibly medieval, site. The best example is the de Lacy Arms, but there are others. The tall, brick-built houses shown in the more recent photograph are parallel to King Street and are much younger, dating from the mid-eighteenth century. They were built as large private houses but some of them are now shops. Either side of the row are more modern buildings, the earliest from the late eighteenth century. Some of these are built of stone.

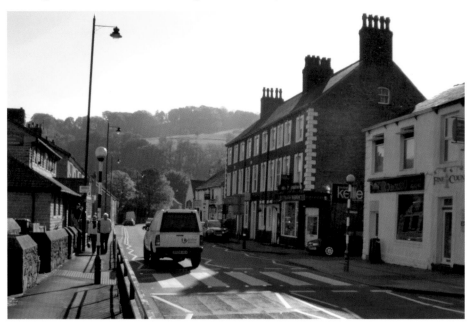

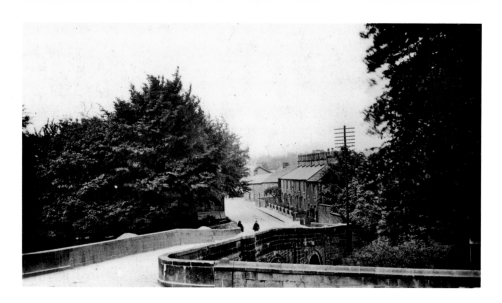

Whalley Bridge

There was a bridge at this crossing point over the Calder in the days when the monks were in residence at the Abbey. Whalley Bridge these days looks to be relatively new but if examined from beneath the antiquity of the structure can be determined. Two of the three arches have a ribbed understructure and the bridge has been widened twice, both upstream and downstream. In the eighteenth century the bridge was only 8 foot 6 inches wide though this was wider than another bridge we will meet, at the Lower Hodder, which was only 7 foot wide. Recesses, or resting places for pedestrians, can be seen on both sides of the bridge and they remind us of the days when packhorse trains rather than coaches were the users. The structure of the bridge looks very solid and this is fortified by the fact that the piers come out of the waters of the Calder right to the top of the parapet. The property, to the right in the newer photograph, includes the Toby Jug Tea Rooms which was originally the sixteenth-century King Street Farm. The river is the boundary between Whalley and Billington.

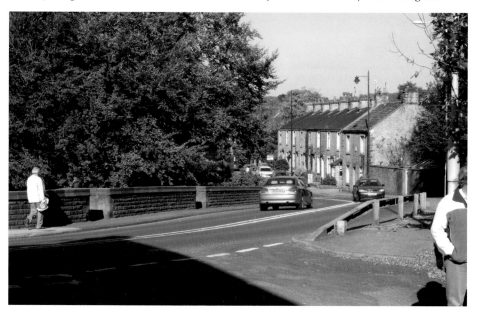

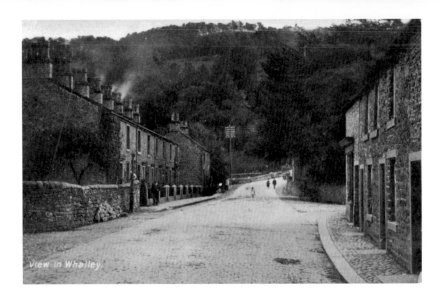

King Street, Looking Towards Whalley Bridge

These pictures have been included because they give the reader an accurate impression of how the village is set in and linked to the landscape. In the distance Whalley Nab can be seen. A 'nab' is a small hill but this tree-covered expanse of land dominates the village and from the top of it there are some splendid views across the valley of the Ribble. Whalley Nab is not in the parish these days though it was when the parish extended almost as far as Rochdale. In the foreground the nineteenth-century stone houses, which are out of favour in many northern towns, contrive to look quite charming in Whalley. The Toby Jug is situated just beyond the terrace but what you might not realise is that there are two bridges here – Whalley Bridge, which we have already mentioned, and the small bridge that carries King Street over the mill race that once carried water to Whalley's Abbey's Corn Mill, which was situated just off the picture to the right.

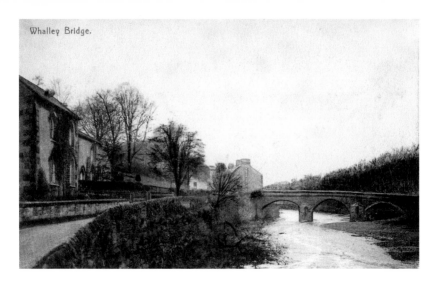

Whalley Bridge.

The Calder from the Marjorie

The Marjorie is the charmingly named former farm building on the left of the modern picture. The Calder can also be seen and, in the distance, is Whalley Bridge. Some references give the alternative name of Calder Bridge, clearly because of the river, which is substantial at this point. The Lancashire Calder, to distinguish this river from the one of the same name in Yorkshire, rises a few yards apart in the hills above and to the west of Todmorden. One stream flows east (the Yorkshire Calder) but the one we are interested in flows to the west and it very quickly becomes a wide river. Of course, it is joined by the Brun in Burnley; the Pendle Water, between Burnley and Padiham; the Hyndburn, near Accrington, and many other rivers and streams along the way. Eventually, the Calder is absorbed by the Ribble as it makes its way to the sea. The Calder is only a short river but, in the past, it was one of the best salmon and trout rivers in the country. Pollution at the time of the Industrial Revolution put paid to that, but now the Calder is recovering quickly. The name comes from the Old Norse 'Kaldre', which means 'fast flowing' though the speed of the water here is determined by the weir upstream from here.

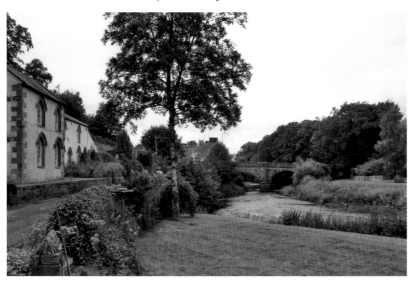

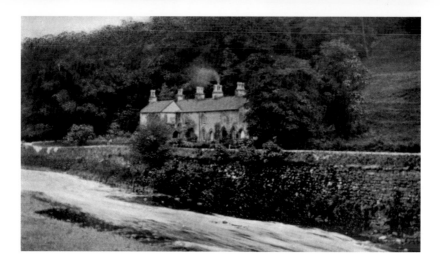

The Marjorie

The odd name of this house gives us the opportunity to look at other names in Whalley and in the area around it. Whalley is an interesting place name as few people other than the natives can pronounce it correctly. Most people say 'Wallie', as in wallet, but the proper pronunciation is wall-ey, as in wall. The name first appears as 'Hwaelleage' in 798 but in the Domesday Book it is 'Wallei'. The first part of the word refers to a hill; the second refers to a field or a flat piece of land near the hill, a perfect description of the location of the village. Billington is across the Calder from Whalley. The name derives from the hill itself which may have been called Billing (or Billinge) at an early date. In 1196 the name was Binningduna, the last syllable being Old English for 'hill'. If that is the case the 'ton' reference, at the end of the place name was added when a settlement appeared at a much later date. Near to Whalley we find Read. Once famous for the quality of its building stone, the name means 'the headland of the roe deer'. Simonstone is much more difficult to determine and the best that can be offered is 'Sigemund's stone', which may have been a boundary stone.

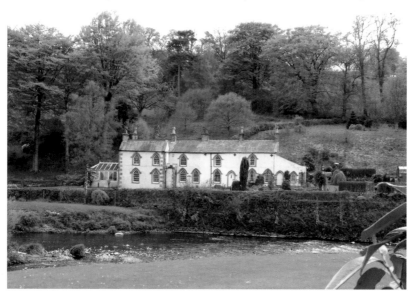

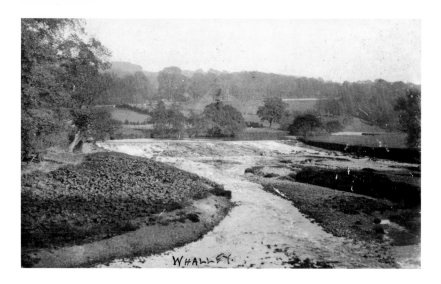

The Weir on the Calder

This is a lovely spot and access to it is easy. Weirs are manmade and this one, it has been claimed, was put in place by the monks of Whalley Abbey to provide water to drive their corn mill in the Abbey grounds. Most monastic houses had their own corn mill but at Whalley, the monks were relative late comers. The village had been in existence for some 600 years before the monks arrived. Whalley must have had its own mill before this time and, as this is the most appropriate place in which to build one, it is possible that the mill powered by the waters captured by this weir was originally owned by some other landowner before the monks took possession of their estate. The weir creates an interesting fall of water but it was intended to make the waters above deeper so that some of it could fall into a race that would take water to the mill. There the waters could be regulated to provide the power to turn the stone mill wheels that would grind corn into flour. The mill itself is on the other side of King Street but the building there now dates only from *c.* 1830.

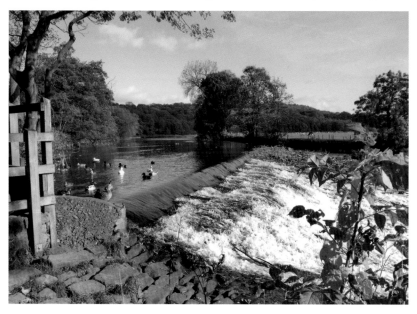

Shops in King Street

The shopping in King Street, George Street and Accrington Road remains surprisingly good. The former Co-operative building provides space for the famous Maureen Cookson ladies clothes shop, Holt's the shoe shop and a good delicatessen. Next door is Whalley's Spar shop. King Street and Accrington Road provide a butcher's, a health food shop, a chemist, the post office, a good hardware shop, an independent wine merchant, several estate agents, a newsagent, a number of cafés and tearooms together with several art shops. In the past the shops were more representative of a typical Lancashire village, the emphasis being on food of which there were quite a number in Whalley. There is no baker in the village at the present time but locals remember four. There were several toffee shops the last one being at 51 King Street, and at least three greengrocers did business in the village. Some of the properties shown here were built as houses and were later converted into shops.

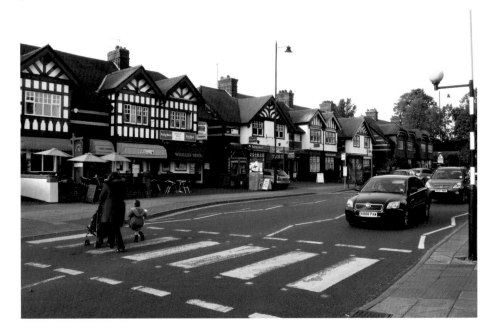

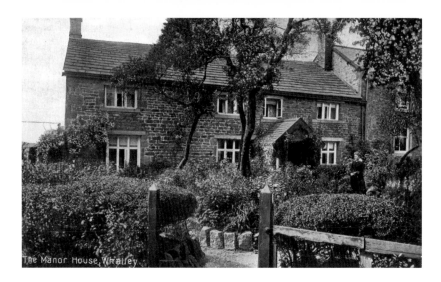

The Manor House, Whalley

The Manor House

This building is now known as the Manor House but originally it was the home of the Brooks family who lent their name to the lane upon which the property stands. The Brooks family were bankers, commencing their business in the village because, at an early time, when they were in the textile business, they had a safe which locals used for a small fee. This side of their business grew and the family became partners in the Blackburn bank of Cunliffe's Brooks. In the nineteenth century the firm established a business in Manchester and, in a part of the city still called Whalley Range, they developed accommodation for their employees. Eventually, Lloyds Bank absorbed the bank founded in Whalley. However, though an interesting building which can be dated to the early seventeenth century and known as the Manor House, this building did not perform that function. For centuries a building on the site of the de Lacy Arms housed the capital manor of the estate. In a way, this made Whalley one of the administrative centres of north-east Lancashire, rivalling the castle at Clitheroe.

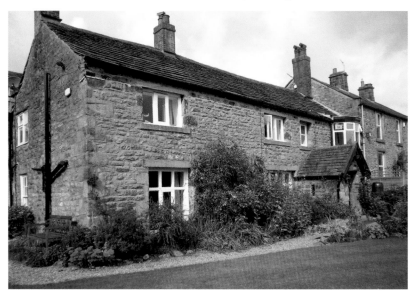

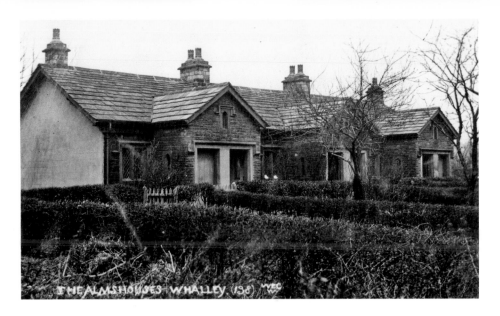

The Adam Cottam Almshouses, Mitton Road

Adam Cottam was a contemporary of Dr Whitaker and he worked with that gentleman on a number of projects involving the church – he helped to raise the money to pay for the armorial window, he paid himself for the south porch and it was he who presented the organ to the church. Mr Cottam is remembered for his association with two other buildings in the village, the misnamed Pig House, where he lived, and the almshouses for which he left funds in his will. Not a great deal is known about Adam Cottam but it is thought that he had some connection with the Whalley family of Clerk Hill. Professionally, he might have been connected with the law but it is known that he was a man of some practical experience, possibly an engineer. He advised on the enclosure of the churchyard and he was involved in a number of agricultural enclosures. It is possible that he was an adviser to the engineers who drained the land around Croston, notorious in the later eighteenth and early nineteenth centuries.

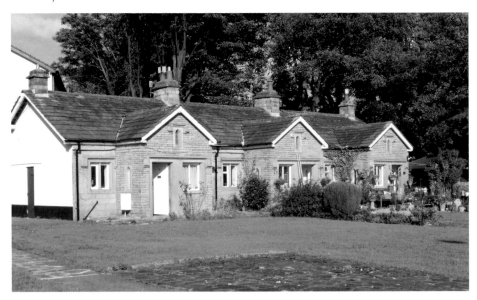

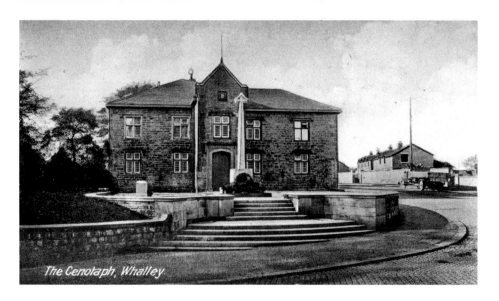

The Cenotaph, Whalley.

Whalley Grammar School

This building dates from *c*. 1725 when Whalley Grammar School moved from the West Gate, near the Abbey where it had been housed almost since the Reformation. The Charter for the school dates to 1549 and was one of a number of schools founded in the reign of Edward VI. Whalley Grammar School was, therefore, five years older than Clitheroe Grammar School and ten years older than the equivalent in Burnley. The dates when schools were founded often refer to Charters but it is generally regarded that Whalley Grammar School was the successor to the school, provided by the monks of the Abbey, for the education of the boys from the better families of the district. It is thought that Sir John Towneley of Towneley may have been a pupil and that members of other influential families were educated there. Where Mitton Road meets Clitheroe Road and King Street the village stocks could have been found in the years when they were used for the punishment of minor misdemeanours. This gave rise to the name Stocks Hill, the old name by which this area was known. As you can see the war memorial of 1921 is situated here.

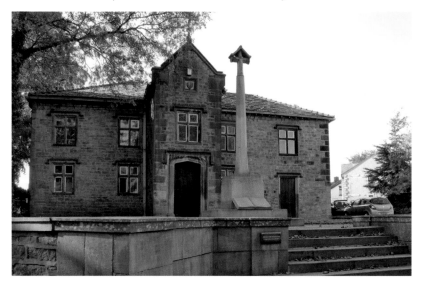

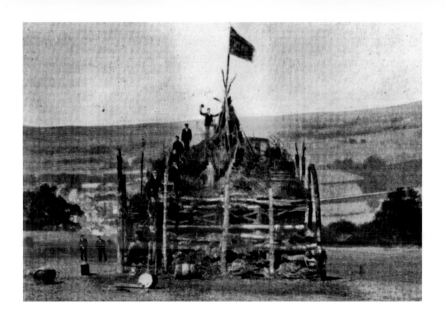

Whalley Nab

Whalley is fortunately situated as the more recent picture indicates. Here we are looking down Abbey Road on a pleasant afternoon in 2011 only months away from Queen Elizabeth II's Diamond Jubilee. The older picture shows the bonfire on Whalley Nab, which was made to celebrate Queen Victoria's Diamond Jubilee of 1897. It looks as if just about every household in Whalley, and possibly Billington, contributed something to the fire and the men folk have carefully thought out how they plan to keep everyone safe whilst, at the same time, ensure a roaring celebratory fire. On the left of the picture you can see the village where there must have been hundreds of people going about there everyday lives but thinking of the great spectacle of the fire. Today there is no trace of the event but if you live in Abbey Road, and other Whalley streets, you can look up and relive the spectacle.

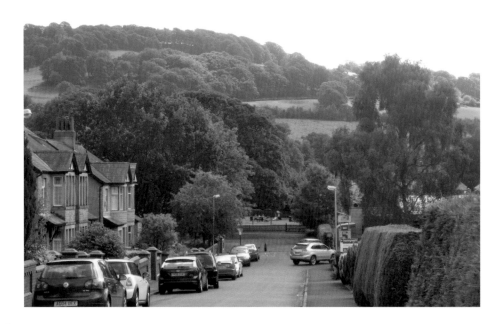

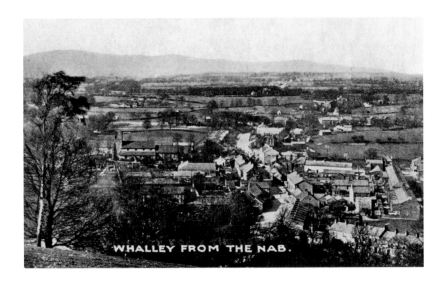

WHALLEY FROM THE NAB.

Whalley from the Nab

We should not leave the village without seeing it from the Nab. The hill is actually in Billington but climbing it is worthwhile because there are spectacular views of the Ribble Valley to be had. In fact much of the area covered by this book can be seen from the Nab and, on a fine day, an interesting time can be had from this vantage point attempting to locate the squat tower of the ancient church of Great Mitton and the green cupolas of Stoneyhurst College, one of the country's most famous centre's of Roman Catholic education. Both of these buildings find space in this book as do many more of the places which can be seen from the Nab. Almost at your feet is the village of Whalley with its surprisingly irregular main streets, its inns and shops, the parish church, which we have visited, and the remains of the Abbey which we are about to examine. As you can see a lot has changed since the firm Constantine of Accrington took the postcard image. The village has grown and now houses occupy what were once green fields.

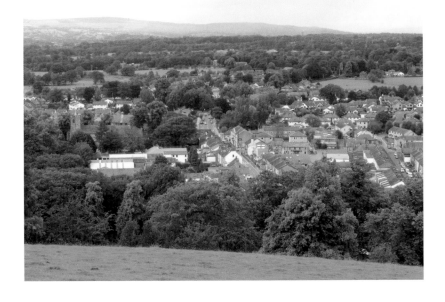

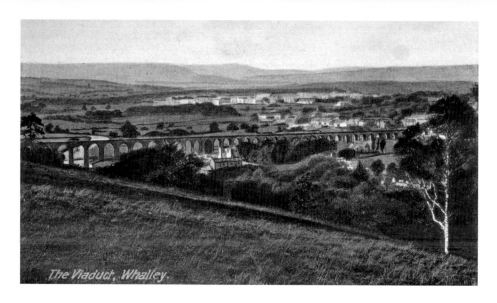
The Viaduct, Whalley.

The Viaduct, Whalley

Most people in Whalley know that the great feature to the west of the village is a viaduct but hardly anyone uses that term. To locals this has long since been 'Whalley Arches' which were completed in 1850. The line carried passengers and goods from Blackburn, Wilpshire, Langho, Whalley, Clitheroe and Gisburn to Hellifield, where this line joined what we now call the Settle to Carlisle railway. The actual line was built by the Bolton, Blackburn & Hellifield Railway, which became part of the LMS. It remained open until 1962 but the line was not taken up and, in the last few years, there has been something of a renaissance with the stations at Clitheroe and Whalley reopening. The development, in the middle distance in the older image looks to be Calderstones, now a housing development, formerly a hospital but originally an asylum.

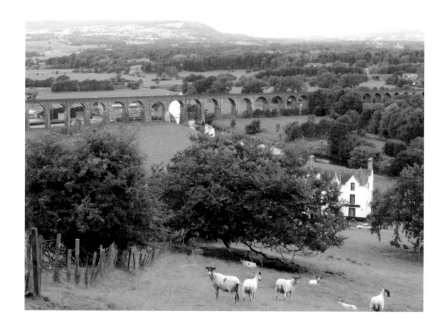

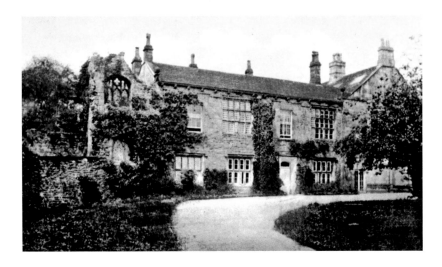

The Oratory or de Cestria Chapel

Accounts of the Cistercian Abbey of St Mary of Whalley usually commence with an account of the foundation of Stanlaw Abbey in Cheshire but here we will start by making our way to the remains of the thirteenth-century Oratory, which can be seen on the left of the old photograph. Though in ruins, like much of the Abbey, it was here, in a house which served as a rectory which had its own chapel had its own chapel, that Peter de Cestria lived. He was the builder of the property, which dates from *c.* 1249, and is now the oldest building within the Abbey precinct. Peter of Chester, as his name would be in English, was probably the illegitimate son of John de Lacy, the first Earl of Lincoln (created 1232). Peter was appointed Rector of Whalley in 1241 but, as he was not in holy orders, he paid clerks to carry out many ecclesiastical duties, not only in Whalley but over wide areas of the country. He was allowed to keep the incomes from them which made him a very wealthy man. Peter was also very long lived, being Rector of Whalley for fifty-four years. Towards the end of this time he knew that the Abbey of Stanlaw wanted to remove itself to Whalley, but the Rector managed to delay the move for many years.

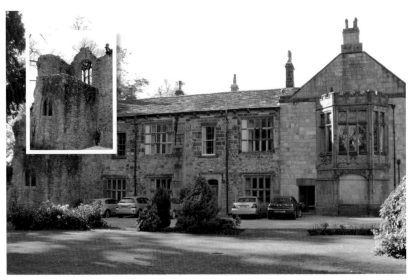

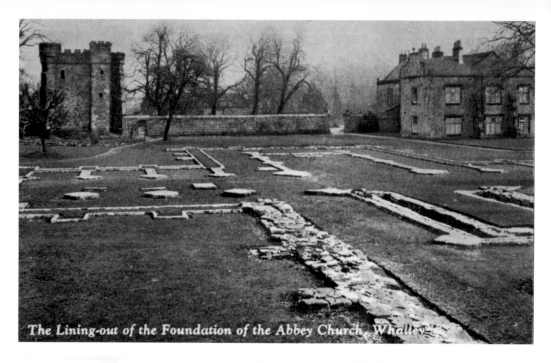
The Lining-out of the Foundation of the Abbey Church, Whalley

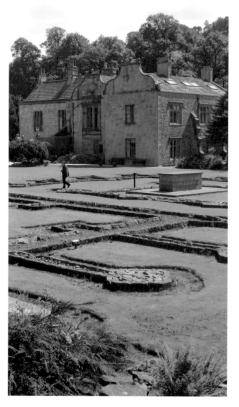

The Foundation of Whalley Abbey

Whalley Abbey can claim to have been founded in 1178 but, for over 100 years, the buildings were in Cheshire not Lancashire. The founder was John, Baron of Halton and Constable of Chester. The site was on the Wirral, near modern Ellesmere Port, and it was colonised by Cistercian monks who came from Combermere near Whitchurch in Shropshire. In 1193 Robert de Lacy died and his estates passed to Roger, the son of the founder of Stanlaw, who adopted the de Lacy name. In 1279, when Henry de Lac was head of the family and one of the most powerful men in England, Stanlaw was flooded by the ever rising sea. It was then that the first application to move the Abbey to safer ground was made and in 1283 it was agreed by Earl Henry that a move should be made to Whalley. To make things easier he granted the advowson (the right to appoint the Rector) to the Abbot of Stanlaw. This effectively put the chosen site for the new Abbey (the glebe of Whalley) into the hands of the Abbot but Peter de Cestria, a formidable man, was not to be moved. The Bishop of Lichfield agreed in 1285 and two years later the monastic buildings at Stanlaw succumbed in a great gale. In 1295 Peter died and, one year later, the monks of Stanlaw made their way to Whalley. The older picture here shows, left to right, the inner gatehouse, the remains of the Abbey church and the rebuilt site of the Abbot's Lodgings.

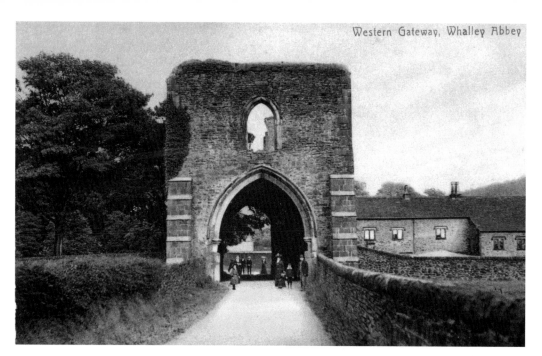

The Monks Arrive

It was on 4 April 1296 when Abbot Gregory left Stanlaw. He had twenty monks with him but he left a handful of monks at the former Abbey, which became a grange of Whalley. When the monks arrived they occupied Peter of Cestria's house and spent little time in getting Earl Henry to lay the first stone of their new Abbey. However, the people of Whalley were not disposed to welcome their new overlords and the monks of nearby Sawley Abbey, which was also Cistercian, were soon in dispute (1305) with their new neighbours. There were rules about the distance between the houses of that Order and the arrival of a new Abbey at Whalley broke them. However, the new house had patronal permission, that of the bishop and, importantly, also that of the Pope. The disputes continued apace and when, in 1316, a grant of land in Toxteth (Liverpool) was made Whalley applied to the Pope for a move to this place. It was, of course, refused and by 1319 the monks had come to the realisation that Whalley was to be their home whether they liked it or not. The monks also came into the possession of a new quarry in Billington in that year and it is likely that the NW Gateway, which is seen in these pictures, was commenced at that time. Note the now demolished cottages on the right.

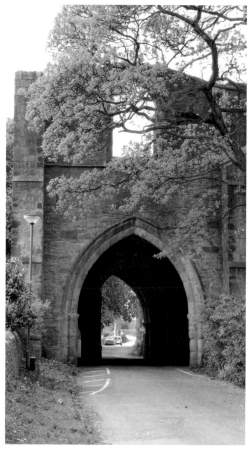

41

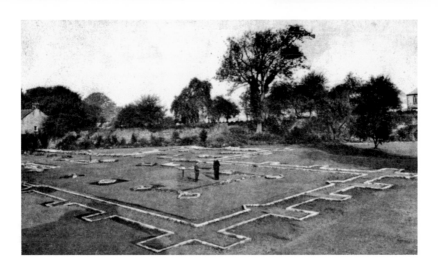

The Building of the Abbey Church

It was in 1330 that the building of the Abbey church commenced. The pictures here show the site of the Lady Chapel and the site of the High Altar, which, in recent times, has been marked by a modern stone altar used in occasional outdoor services. Another point worth noting is the wall and raised land that runs across the centre of the photographs. These are the remains of a precinct wall, the original of which was commenced in 1339. Most monastic houses were defended by high walls which were pierced by solidly built gatehouses and this was particularly important at Whalley because building commenced during Edward I's Anglo-Scottish Wars; in other words, at the time depicted in the film *Braveheart*. The system of walls at Whalley is not fully understood as they were removed many years ago probably for building material when the Abbey was surrendered to King Henry VIII. The Abbey church is 260 foot long and is approximately the same length as Ripon Cathedral. A building of these dimensions might seem excessive for only a small number of monks but Whalley was really two churches. The Chancel was used by the monks but the nave, to the left in the older picture, was used by the Lay Bretheren and the Abbey's many servants.

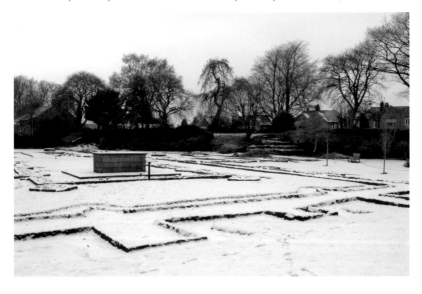

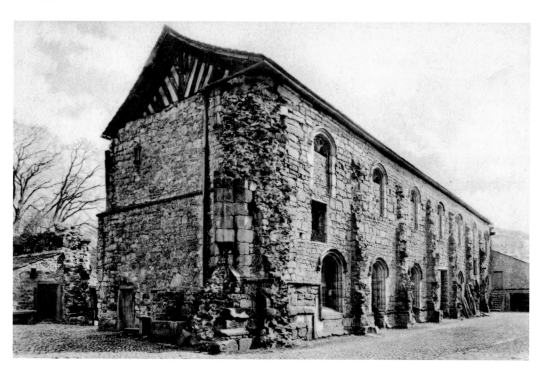

The Lay Bretheren's Dorter I

A 'dorter' was a dormitory for sleeping and it was here that the Lay Brothers slept. The older picture makes it clear that this building had two floors. The lower one was the large storeroom run by the Cellarer, who was responsible for supplying the Abbey with fuel, food and drink. Lay Brothers were not priests. Being from the lower, and often unlettered, classes their role was to undertake the physical and menial work that was needed in the fields, the brewery, the kitchens, etc. Some Lay Brothers had particular skills and they were builders, workers in wood (like Eatough whom we have already noted), makers of tiles and even designers of buildings. Others were calligraphers, and makers of the host for the Mass. They were also known as 'conversi' or 'barbati' – the bearded ones – and it is from the later word that we get our word 'barbarian'. In the high Middle Ages, large numbers of Lay Bretheren came forward for a monastic life that was in itself regarded as an honourable calling. In later years fewer Lay Bretheren were available just as there were fewer monks.

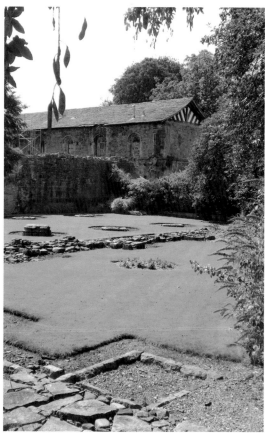

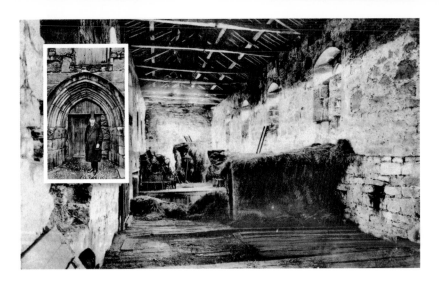

The Lay Bretheren's Dorter II

This is one of the best preserved parts of the Abbey though it is in the ownership of the Catholic Church rather than the Church of England which has the rest of the site. The two churches have worked well together and they have had plans, so far unrealised, to convert this building into a Christian Heritage Centre for some years. The building was used for religious worship by the Catholics before they built their own church, English Martyrs. One of the older pictures shows the interior of the building at the time the Catholics acquired it. This is the ground floor where the Cellarer operated and where this monk, who was very important to his community, stored the things of this world which made the monks' lives tolerable whilst on this Earth. It is to be hoped that one day the vision of the two churches can be achieved and that a facility which may attract many more people to the site than currently make their way to Whalley.

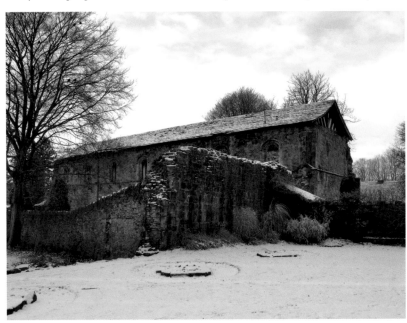

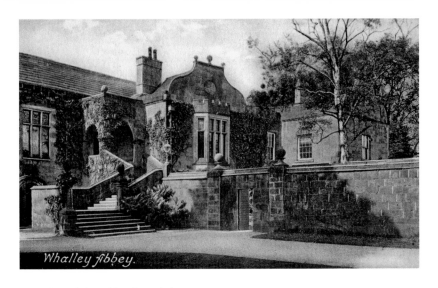

Whalley Abbey.

The Site of the Abbot's Lodging

The Abbot of Whalley lived in some style but the site of his lodging has been the cause of some dispute. He was not only an abbot, with an important monastic house in his care; he also had the status of a bishop – a Mitred Abbot. We know little about the first building on this site though remains have been found of what is thought to have been the abbot's lodging between this building and the Chapter House (see below). The building is described as being not unlike a small manor house. It had a great hall, complete with fire place, an oriel window and a western wing which must have had an upper storey because four steps of a spiral staircase have been found. However, this possibility does not accord with everyone's opinion of what the Abbot of Whalley should have lived in. They suggest that the building shown in these photographs occupied part of the site of a larger abbot's lodging and that the small one described above was only temporary or intended for someone else within the community. What we do know is that when the monks left Whalley, in the sixteenth century, those who came after them used the Abbey as a quarry and built the property you see in these pictures making it their home.

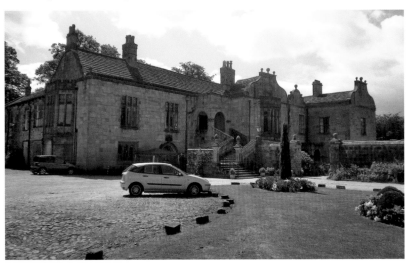

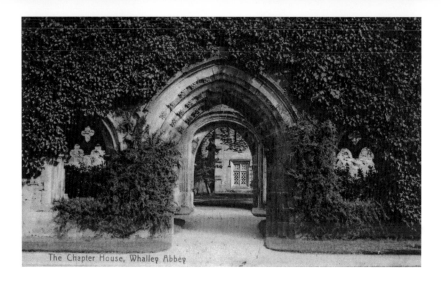
The Chapter House, Whalley Abbey

The Chapter House

Whalley's Chapter House is, like much of the Abbey, a roofless ruin. In itself we would be able to say little about it but Cistercian houses conformed, depending on their individual sites, to a plan which was common to the Order. Here we see old and modern photographs of the entrance of the Chapter House. Confusingly, some are of the opinion that the building is more likely to have been the Scriptorum. However, the confusion might be the consequence of nothing remaining, above ground, of the Chapter House which was an octagonal building in front of this doorway. The Chapter House gets its name because it was the regular and official meeting place of the monks. A Convent of monks is called a 'Chapter' and they met together to discuss issues which affected the running of the Abbey and its estates. These matters might be religious but they might just as well be about economic or social problems. The Chapter met to elect a new abbot when that became necessary through the resignation or, more commonly, the death of the abbot. Nothing remains except the doorway at Whalley but many Chapter Houses had seating arranged around the sides of the building with a special place reserved for the abbot.

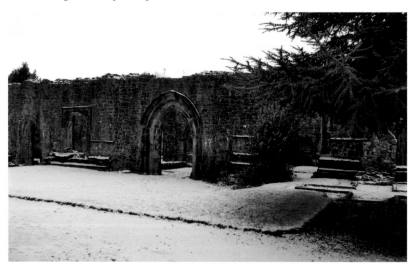

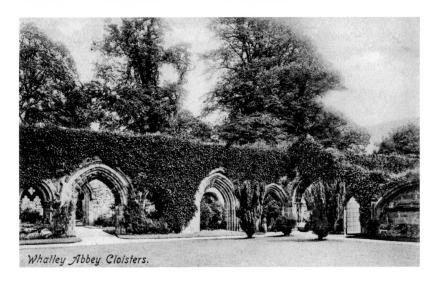

Whalley Abbey Cloisters.

The Abbey Cloisters

The word 'cloister' can mean different things to different people. It comes from Middle English and the Latin *clausum*, which means 'to shut' and it is from this that we get the word 'cloistered', to be confined. A place of religious retirement, to confine within walls, the monastic life – all fall into this category. However, what we are referring to here is a covered arcade which is part of a monastic or collegiate establishment. The cloister at Whalley was a covered walk, walled on one side and open to a court or quadrangle on the other. This cloister here conforms to others in the Order in that it is on the south side of the church but, in the past, there was a lawn in the centre with a paved walk on all four sides, covered by a wooden penthouse roof supported by pillars. The places at which the roof supports fitted into the walls can be seen as can some of the bases of the supporting pillars. The eastern range of buildings housed the monks' dorter with a place for night stairs (access to the church) at one end and the day stairs at the other. The openings, common to all Cistercian houses, gave access to the monastic book collection, the Chapter House, through a room that might have served as the Scriptorum, and other rooms including the Parlour which was kept welcomingly warm.

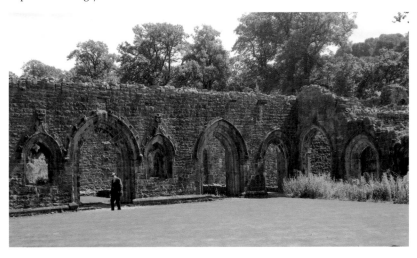

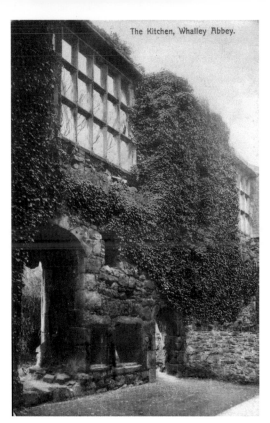
The Kitchen, Whalley Abbey.

The Kitchens

It is not possible to call these the Abbey kitchens because they have been altered by later owners of the buildings. The buildings are very impressive even though they are roofless and have been for many years. An establishment as large as Whalley Abbey was, at its height, needed more than one kitchen. The Abbot had his own, partly because of his status within the community but also because he often entertained important visitors to the Abbey. There might have been kitchens in other parts of the building – the infirmary for instance – and other fireplaces, where cooking could be undertaken, have been found during excavations at the site. The truth about Whalley is that when it ceased to be an Abbey it was occupied by the Bradylls, the Asshetons, the Curzons, the Hargreaves, who, without destroying the monastic buildings entirely, did rather a good job of eradicating structural evidence relating to the use made of some of the buildings.

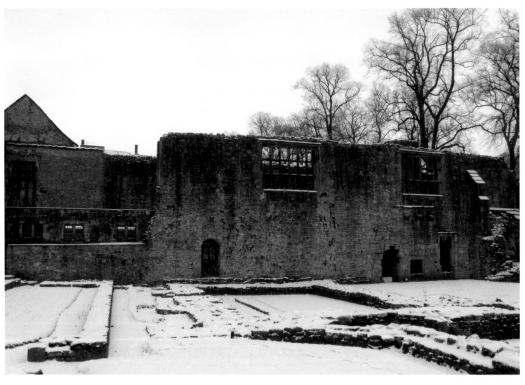

The North-East or Inner Gateway of Whalley Abbey I

This gateway, which dates from 1480, serves as the present entrance to the Abbey grounds but was initially intended to give access to the Abbot's Lodging and to his important guests. There is a problem about access to the Abbey in the days when it was in use for monastic purposes. When first built the Abbey had a precinct wall of which nothing or very little remains today. It is likely that this wall had four gateways, only one of which survives today. This is the NW Gateway and if it is the only remaining gateway of the four precinct gateways the one you see here is a fifth. The problem is that no one is sure about how many gateways there were. This one is very different to the one to the NW of the present property though it, too, has an upper room. The north-east of Inner Gateway is from the Perpendicular period of architecture and it has battlements and buttresses. The artist Cattermole, in a study of the last days of Whalley as a religious house uses this gateway as a backdrop to the event when John Paslew, the last abbot, was lead away for trial and execution for his involvement in the Pilgrimage of Grace. A point worth mentioning is that, in the niche, it is likely that there was once a stature of St Mary of Whalley.

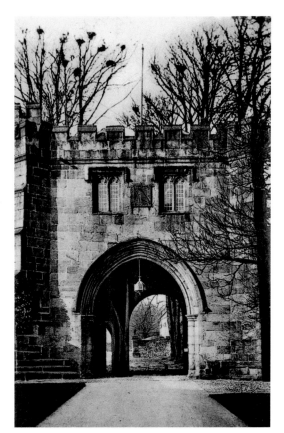

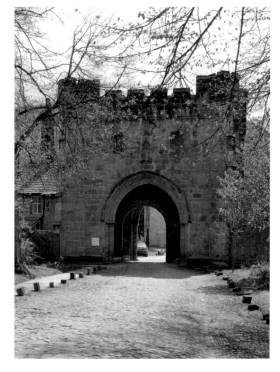

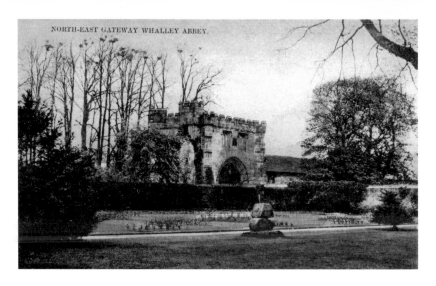

NORTH-EAST GATEWAY WHALLEY ABBEY.

The North-East or Inner Gateway of Whalley Abbey II

These pictures are included because this gatehouse is the best preserved part of the Abbey. It still provides useful service, with its ancient doors, as the official entrance to the present site and the range of buildings to the right contain a book and gift shop, a tea shop and a small museum. Perhaps the most interesting exhibit in the latter is a wonderful model of the Abbey when it was at its most complete. Whalley Abbey must have been a most impressive sight. Its huge church could be seen from miles around just like Ripon Cathedral can be seen today. In fact Whalley, because of its situation and the height of its buildings, would have been even more impressive. The other exhibit worth looking at is the information on the fantastic fifteenth-century altar vestments worn, when saying Mass, by Whalley's priests. Miraculously, they have been preserved and they can now be seen in Burnley Borough Council's Art Gallery & Museum at Towneley Hall, which is only ten miles away. The gateway leads to the Courtyard which provided parking for those working at the Abbey, which is now mostly owned by the Blackburn Diocese and is operated as a Conference House with accommodation.

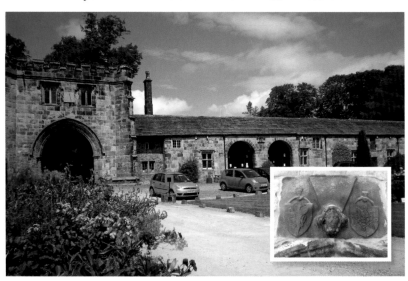

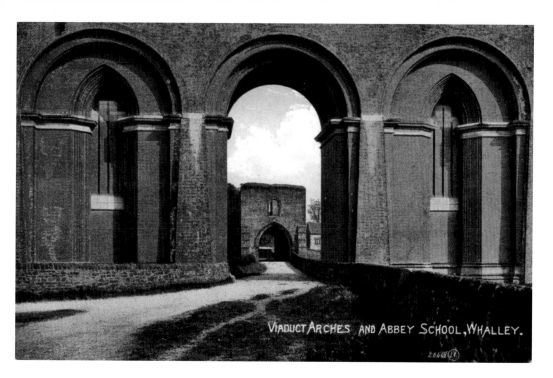

VIADUCT ARCHES AND ABBEY SCHOOL, WHALLEY.

Whalley Arches and Abbey School

It might seem odd to write about medieval architecture when illustrating it with photographs of a railway viaduct of 1850. There are several good reasons why this device has been used. When the railway company came to build what is properly called the Whalley Viaduct they found that the owners of the Abbey, then a private house, wanted the builders to respect the architectural integrity of the ancient monastic building. It was agreed, therefore, that the arches, either side of the road which leads to Broad Lane, should be constructed in the Early English, or Lancet, style of around the time the Abbey was built. The two brick arches are impressively lancet-shaped and pointed like a knight's lance. Another reason is that precious little has survived of the architectural detail of Abbey itself. Through the centre arch, in the top picture, you can see the West Gate of the Abbey. This once provided accommodation for both the Abbey and Whalley Grammar schools. We have noted that the Grammar School moved to the building in Whalley village in 1725. It could be that the West Gate was saved because it continued to be used for so long after the Abbey was suppressed.

51

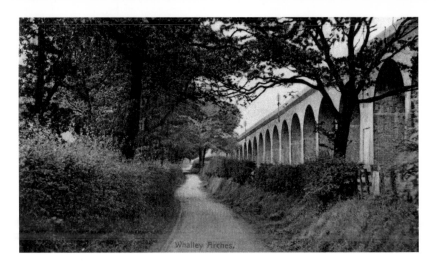

Whalley Arches.

Broad Lane and the Viaduct

We can't leave this part of Whalley without mentioning something of a mystery which, as yet, remains unresolved. The railway viaduct is, as is evident, parallel with Broad Lane but there is third feature hidden here. This is a massive earthwork, one of several which exist to the west of the village. Others can be located north of Pool End, north and west of the parish church and at School Croft, west of the Abbey. There has been much speculation about what these earthworks were for. This includes the boundary of a settlement site dating back to the Bronze Age, the precinct 'walls' of a Celtic monastery and medieval fish ponds. The debate has been confused by the use of the word 'canals' which is seen on early maps especially those prepared for Ashton Curzon in the mid-eighteenth century. Whalley does not have a canal in the proper sense of the word though the early builders of the Leeds & Liverpool Canal proposed a route which would have come close to the village. It is likely, therefore, that the 'canals' were moats protecting some ancient property; a Celtic monastic cell is a possibility. However, it has been claimed that Whalley has an almost forgotten Roman history which should be reclaimed and that the 'canals' might have something to do with them. Another factor that should not be forgotten is that Whalley once had a mill other than the famous Abbey Mill. This mill was also powered by water and it might have a role in the mystery.

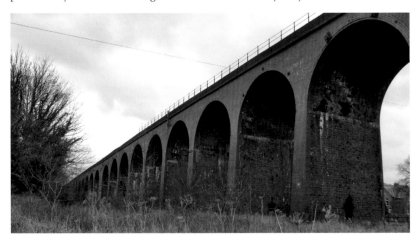

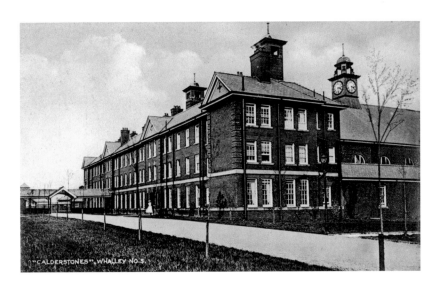

Calderstones

It would not be an exaggeration to indicate that Whalley was once dominated by Calderstones which was one of two massive hospitals for people who suffered from mental health problems. The other was at Brockholes at Old Langho, which is to the west of Whalley. Calderstones, as the name implies, was situated on the banks of the Calder but Brockholes was on the banks of the Ribble, just below its confluence with the Calder at Hacking Hall. Calderstones was so large that housing had to be built for those who worked there and much of this property can be seen on the Mitton Road. During the last war, Calderstones served as St Mary's military hospital and the father of one of the authors of this book spent some time there after his return from POW camps in North Africa, Italy, Eastern Europe and, latterly, Germany. In recent years the methods of caring for those with mental health problems have changed and land at both Calderstones and Brockholes has been released for a number of purposes including housing as the more recent photograph here indicates.

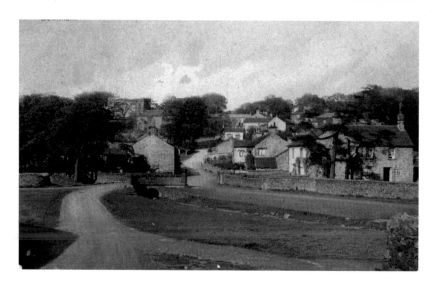

Downham Village

Taking into account its name, it might be expected that Downham might be in a valley. Nothing is further from the truth in that the place name actually means 'the hilly village or estate' from Dunum (1194). The first syllable of the old name means 'hill' or hills and Downham is a very hilly village. It is also very pretty, perhaps the prettiest in Lancashire. The village is almost entirely owned by Lord Clitheroe, whose ancestors, the Assheton's, after the Suppression owned Whalley Abbey. The village has everything that a typical English village should have – a lovely parish church, a 'big house', a village green, an old inn, the remains of the former village well, a village shop, an old water mill and the village stocks. The latter is not used these days and neither is the former Wesleyan Chapel which, though still standing, is now put to community use. Downham achieved some fame inn 1961 during the filming of *Whistle Down the Wind* which starred Alan Bates and Hayley Mills. Some scenes were shot in the village and on nearby Worsaw Hill and Worsaw End Farm. In recent years a popular television series *Born & Bred* was filmed in Downham. Visitors are still attracted to the village because of these and other films made in the area.

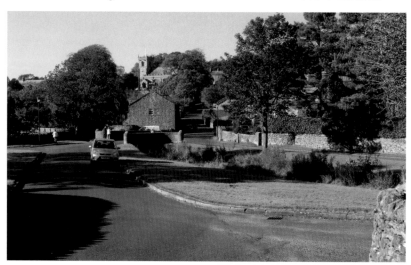

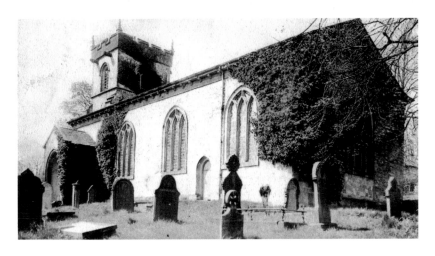

Downham Parish Church of St Leonard

There has been a church in Downham for over 700 years. It has been rebuilt several times but when work was carried out in 1910 Saxon or early Norman foundations were discovered. The church predates Whalley Abbey but, after 1296, the Abbey provided priests to say Mass at St Leonard's. It was not until the middle years of the sixteenth century that Downham got its own priest. The oldest part of the building is the western tower which dates from the latter fifteenth. In it are hung the churches fifteenth-century bells, three of which, at one time, were thought to have come from Whalley after its suppression. However, it is more likely that the bells were cast for this church. Inside, the church is light and airy and there is some good stained glass to admire. Also much in evidence are the memorials to members of the Assheton family. In fact just about all of the memorials in the church have Assheton connections. Perhaps the best is to the First Baron Assheton who was MP for Clitheroe from 1935–55 when he was created a baron in recognition of his wartime work in Churchill's government. The church is well known because of the view of Pendle Hill from the porch. Queen Mary, the consort of King George V, considered it to be the finest view from a church in all England. A modern photograph of the same view is included.

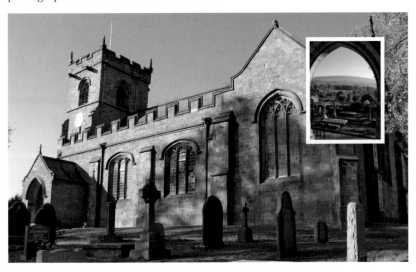

55

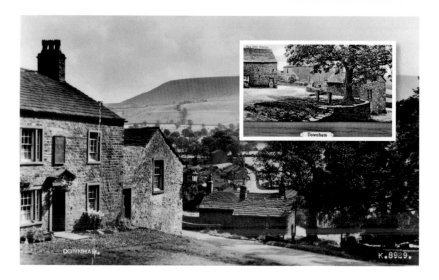

The Assheton Arms

This is the village inn of Downham. It is situated opposite the parish church and it dates from the eighteenth century when it was known as the George & Dragon. That name was still in use when the older of the two photographs was published as a postcard by Valentines. There must have been an inn on this site before the present building was constructed and, in the past, like so many village inns the landlord also carried on the business of a farmer. The inn was put to many uses – a local court was held here, rent collection days for the estate (twice yearly) used the premises and it was from here that the village Benevolent Society was run. All of these would have brought in extra trade for the innkeeper. If you examine the older of the images you will see the famous Pendle Hill, associated with tales of seventeenth-century witchcraft, in the background. Notice, also, a small plot of land on the right in the photograph. This, as you can see, contains a small bench but, just to the right of it, you may be able to see the remains of the village stocks in the shadows cast by the trees. We have included an image of the stocks as they were before 1909.

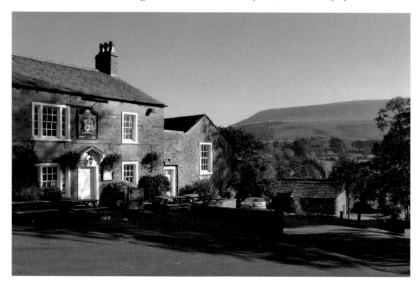

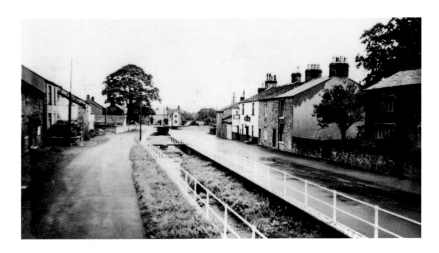

The Village of Pendleton

Another pretty village close to Pendle Hill, this time taking its name from the famous hill itself, is Pendleton. The village is mentioned, as 'Peniltune', in the Domesday Book of 1086 and is one of the few places in the district to be picked out for that honour. The village is well known for its public house, the Swan with Two Necks. The sign shows just that but the name derives from the English tradition of 'swan upping', which takes place along the River Thames each July. The swans, long since regarded as a royal bird, are taken by 'swan uppers', who represent the Crown, and the representatives of the Vintners and Dyers. The 'swan uppers' return the bird to the water unmarked but the beaks of the swans counted by the Vintners and Dyers are marked, or 'nicked', two for the Vintners and one for the Dyers. Over the years the word has been corrupted to 'necks' and the improbable 'Swan with Two Necks' was born. Pendleton has only one street that has a number of interesting former farmhouses, barns and cottages from the seventeenth and eighteenth centuries, though the buildings that date from the nineteenth are in no way out of place. Within the parish are the remains of Wymondhouses, a centre for dissenters in the seventeenth century, and Little Mearley Hall, a charming sixteenth-century property.

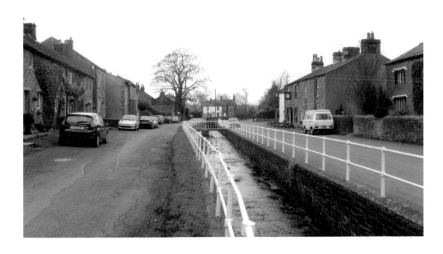

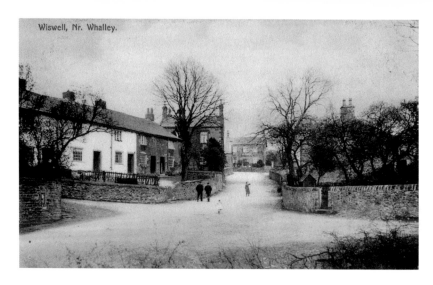

Wiswell, Nr. Whalley.

The Village of Wiswell

This charming little village is near Whalley. Its name is from the Old English 'wise' and 'wella'. In 1207 it is given as Wisewell but the meaning of the name is more complicated. The first element derives from 'wiese', which refers to a muddy meadow, and the second not to a well, as we would recognise one, but to a spring or a stream. So Wiswell refers to a badly drained and muddy meadow through which flows a stream. Wiswell has an interesting history but it has no outstanding properties, although the older buildings and the newer ones blend well together. Vicarage House is an early seventeenth-century building and has mullioned windows, a door from the Tudor period and coped gables with finials. However, the village has some hidden gems, including several handloom cottages and a small corn mill, now occupied as a house, which was once an inn, the Black Lamb. Wiswell also had its own National School of 1831 now also a house. The New Row, which is shown in the photographs, is a very good example of their type. The village inn, these days, is the Freemason's, a splendid restaurant on the chocolate box surroundings of Wiswell.

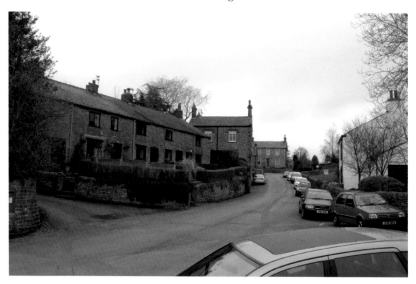

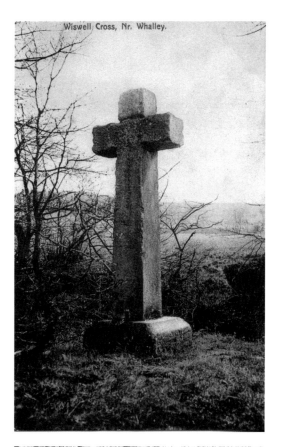

Wiswell Shay Cross

The area covered by this book once had numerous roadside crosses similar to this one, which still stands in Wiswell. The purpose for which many of the crosses were intended has long since been lost but a number of potential reasons for erecting them can be identified. These include preaching crosses, churchyard crosses, market crosses, boundary crosses (sometimes known as merestones), crosses at road junctions, crosses that mark holy wells and crosses used as guide posts. There are also weeping crosses, which were marked places for funeral processions to rest on their way to the distant parish church. It is not known what the simple Wiswell Shay Cross was intended for but it is known that it was restored in the late nineteenth century and has been kept in good repair ever since. There is another cross with Wiswell connections. It was situated at the junction of Wiswell Lane and the Clitheroe Road out of Whalley on land now occupied by Pig House. We think that we know what the purpose of this, the Wiswell Lane Cross, might have been. The plot of land between the two roads is known as Guide Post Field so it is assumed that this was the function of the former Wiswell Lane Cross.

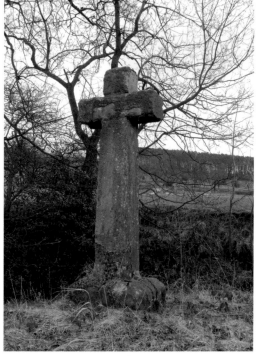

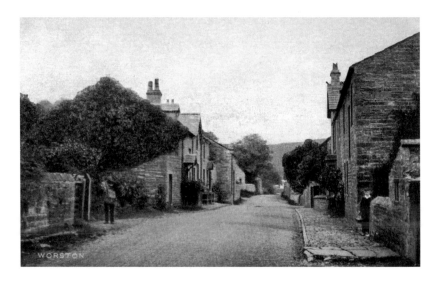

Worston

When the most recent edition of *Buildings of England* (BoE) series was published we were surprised to learn that Worston had been completely omitted. There is property in the village that is certainly worth a mention but it could be that the compilers of the book are not the first to get Worston and Worsthorne, the village near Burnley, mixed up. On reading the entry for the latter there is no reference that should accompany an entry for Worston but the BoE are not the first to succumb to this confusion. The editor of the *Blackburn Mail*, which ran from 1793 to 1832, was frequently guilty and it is still not possible to work out which village entertained certain events. Worston is well known for two things, the Calf's Head Hotel and its former Mock Mayor. The latter was little more than a drinking club for the men of the village who would tell their wives that they were going to a Council meeting. The trouble was that the meeting took place in the Calf's Head! Some years ago before the hotel was extended and modernised the bar had a display of the Mock Mayor's Robes and other thing associated with the 'office' but they, along with the merry meetings, have been consigned to history. Worston does not have a Parish Council, rather it has a Parish Meeting, which is shared with Mearley.

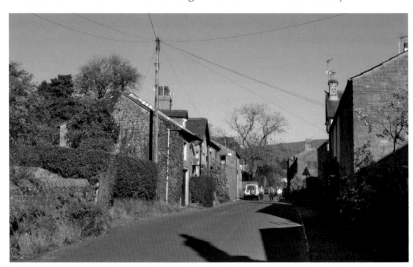

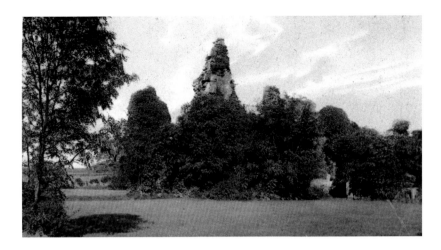

Sawley Abbey

We have already visited the Abbey remains at Whalley but the area has an even older monastic establishment at Sawley, which historically was in Yorkshire rather than Lancashire. The Abbey is on the banks of the Ribble and, as you can see, not much remains of the property, which was founded by William de Percy in 1147. This was 149 years before the monks of Whalley made the move from Stanlaw. Elsewhere in the book we have made the point that the Cistercian monks of Sawley did not make the newly arrived Cistercian monks of Whalley particularly welcome. Sawley Abbey is situated in beautiful surroundings but, in the early days, the land was very badly drained, crops failed and, by 1200, the monks were thinking of moving to more accommodating property elsewhere in Percy ownership. A few small grants later, the Abbey controlled the churches of Gargrave and Tadcaster. The monks decided to stay but the Abbey was never prosperous. The monks, though, built a reputation for learning and they ran a hospital for lepers in Tadcaster. Sawley is, perhaps, best known for its involvement in the Pilgrimage of Grace, the most serious of the rebellions against Henry VII. In 1536 the monks were ejected from their Abbey and the buildings were granted to Sir Arthur D'Arcy. However, the monks disagreed with this and so did some 200 local families. They persuaded the Abbot to side with them and they joined the rebellion. This failed and the Abbot and two of his monks were executed for treason.

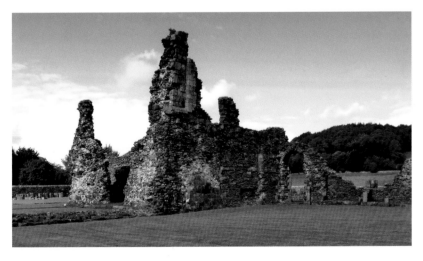

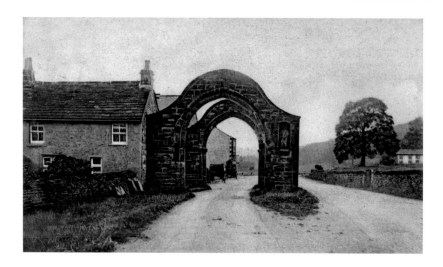

Sawley Village

The remains of the Abbey are within the village of Sawley, which is the modern spelling for 'Sallea', the name by which the place was known in 1162. Later spellings include 'Salleie' and 'Salieleie' of 1195 and the name means 'sallow hill' or 'sallow valley', the 'hill/valley where the willows grow'. A brief walk in the direction of the Spread Eagle will reveal that the Ribble, quite impressive at this point, comes right into the heart of the community. This was a great disadvantage, in the early days, in that the land around the river was permanently wet but, by the time of the Industrial Revolution, the power of the river and the regularity of its waters ensured that the calico bleaching and printing works on the site, once owned by the family of the Victorian Prime Minister, Sir Robert Peel, was a success. Now, like the monastic buildings, few traces of industry remain. Close to the village inn, which is well known for the quality of its food, one of two archways, constructed out of stones from the Abbey buildings, can be seen. When motor vehicles started to bring tourists to the area one arch was demolished but the other was removed to a safer location.

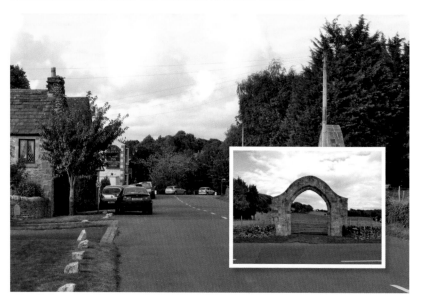

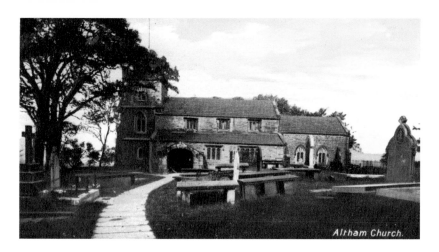

Altham Church.

The Parish Church at Altham

When referring to Pendleton, above, the village inn – the Swan with Two Necks – was mentioned. Not all that far away is Altham, and here the place name means 'the water meadow where the swans are found'. The church, which originally served not only Altham but a very wide area between Burnley and Accrington, is dedicated to St James and it was founded in 1140. It is possible that a place of religious worship existed at Altham before that time as a document refers to the 'monastery' of Altham. No trace of a monastic building has been found but it is possible that there was a hermitage at this place, the hermit helping travellers across the often swollen waters of the Calder. There are traces of the Norman building but the church has been rebuilt on at least three occasions. The first was in the fourteenth century and the tracery of the east window in the north aisle is from this period. The nave was rebuilt in 1512 in the Late Perpendicular style and the chancel in 1859 by Thomas Hacking, whose ancestor, the inventor of the carding engine, is buried in the extensive graveyard. In another connection with Pendleton one of Altham churches incumbents, Thomas Jollie was ejected from his church in 1662 for his nonconformist beliefs and it was he who established the community at Wymondhouses. When in Altham, look for the corn mill of 1816 which replaced another mill mentioned in 1088. The mill survives together with workers' houses of the period on the banks of the Calder.

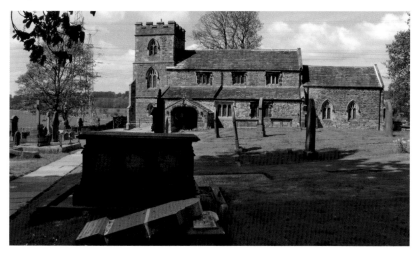

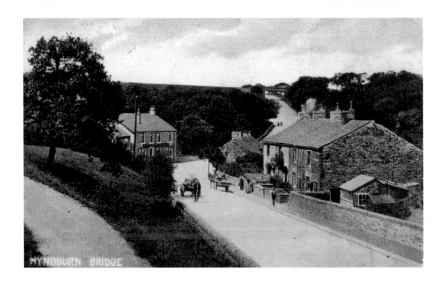

Hyndburn Bridge

These photographs are taken where the road between Whalley and Accrington passes over the River Hyndburn, which itself flows into the Calder only a mile or so to the east. The Hyndburn flows close to the Dunkenhaulgh estate, which has Whalley connections in that the Hall there was once in the hands of the Walmesley family and this accounts for the name of the public house near Whalley Bridge. The river is also close to Tottleworth, which was the home of a notable egg-eating champion. His name was Richard Carter and, in 1795, in the space of one hour and for a shilling (10p) bet, he sucked out of the shells eighty-four raw eggs, drank almost a pint of gin and half a crown's (12p) worth of punch, along with a considerable quantity of ale! The bridge was itself the scene of a remarkable incident only the year before. Two boys were playing near a private path in the fields near the bridge when they found a brown woollen rag that appeared to have something in it. On looking they found forty-nine guineas and one of the boys asked his friend to share the prize. The second boy refused and added, 'Thou shall have the next we find'. News got round about the boys' good fortune and neighbours left their homes searching for money. An elderly lady found two guineas and was very happy. Although the incident was publicised no one came forward with a claim.

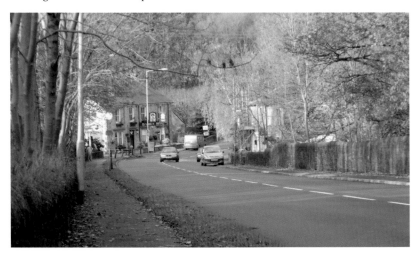

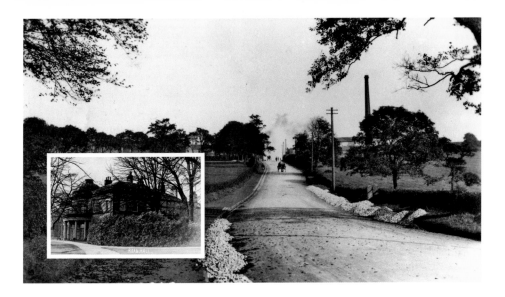

Mercer Brow, Read

This is the view of Read that the traveller from Whalley sees when entering the village from the west. The only thing that is missing (on the left) is the steeple of the parish church. The church, which was built in 1884 and is dedicated to St John the Evangelist, would have been standing when the early photograph was taken but the steeple was not added until 1911. Also, on the left, the upper part of the extensive and rather beautiful park of Read Hall can be seen. Read Hall is a complete rebuild of the house lived in by the Nowell family. They include the famous theologian, Alexander Nowell who was Dean of St Paul's during the reign of Elizabeth I, and Roger Nowell, the magistrate who brought the Pendle Witches to trial in 1612. The Hall dates from 1818 to 1825 and is by the Kendal architect George Webster, who carried out the work for John Fort, a calico printer. The Forts are still remembered in the village though their factories were not based here. On the right you can see the tall chimney of one of the two cotton mills which were built in Victorian times in the Newtown part of the village.

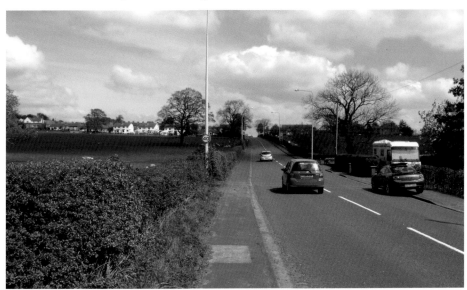

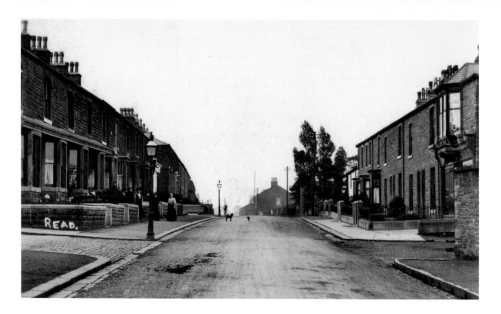

Newtown, Read

The road, a former turnpike on a new route bypassing the road in Old Read, is wide and the footpath, in parts, is newly paved. This part of Read conforms to what was going on elsewhere in Lancashire during the latter nineteenth century. Houses like these can be found in almost all of the industrial communities of north-east Lancashire. Like many others they are stone-built and once Read was very well known for the quality of its building stone. A number of ladies and one gentleman – left – are aware that a photographer is about his work, but have you noticed the cat and the dog almost in the middle of the picture? The sender of the card did and noted, in the 'Space for Communication', that 'It's a cat and dog life in Read!' I wonder if this was a play on words and whether the sender of the postcard had Suffragette sympathies? The 'Cat and Mouse Act' was very much in vogue when the card was posted. Was the Oldham lady who received of the card was amused? We will never know.

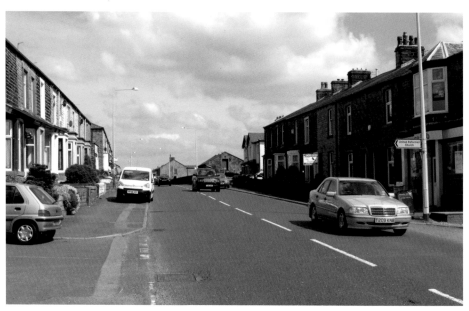

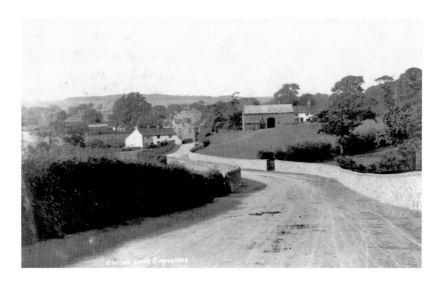

Station Lane, Simonstone

Read and Simonstone are neighbours. As good neighbours should, they do lots of things together, sharing facilities and promoting clubs that serve both communities. The place name is pronounced 'simmon-stone' and it probably comes from a boundary stone that delineated the extent of adjoining estates. The area is still mostly rural and the old family estates are still very much in evidence. In 1278 the name is given as Simondeston. The first syllables may come from a personal name such as Sigemund, but who this person was, if he existed at all, is not known. There was, however a local family named de Simonstone whose estates passed to the Starkie family, who built Huntroyde, a large and imposing house in the township, in 1576. The older image shows property on the Starkie estate just below the turnpike road from Padiham to Whalley. The cottages on the right took their name from the goose meadows that once exited here, but recently, and sadly, the old name has been dropped. In more recent times Simonstone has become a very desirable place in which to live. It has been called 'Burnley's stockbroker belt'.

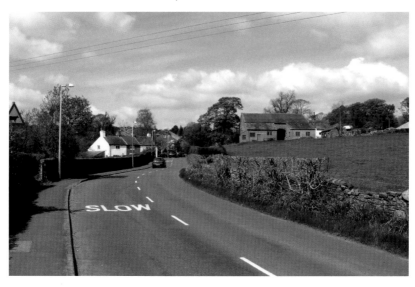

Simonstone School and Church

These buildings are on School Lane, in the heart of Simonstone village. The building, right, is part of what was an early nineteenth-century National School, which was added to in 1879. The whole is now the Mission Church of St Peter and the building is opposite the relatively new replacement school buildings. If you look carefully you will see memorials on the exterior walls of the building. Notice also the little bell tower. The buildings to the left are examples of the individual architect-designed quality smaller houses, of which there are a number in Simonstone. Most of them date from either the end of the nineteenth century or the beginning of the twentieth and they can be found both here, pleasantly mixed in with older properties, and on the south side of the township, but especially on Station Road, as it is now. Not far from where these photographs are taken is an early nineteenth-century toll house, which was known as Simonstone Bar.

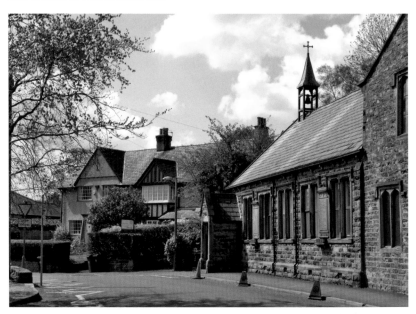

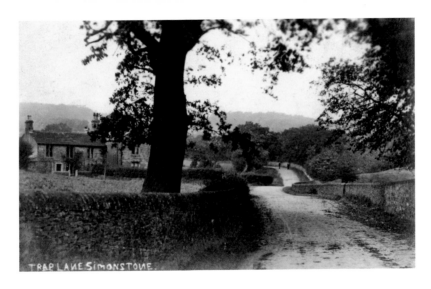

Trapp Lane, Simonstone I

This lane takes its name from the hunting and shooting that once was a significant feature of the three main estates in this area: the Huntroyde, Simonstone Hall and Read estates. The lane is well known because of the blacksmith's at the Higher Trapp and the hotel of the same name. Huntroyde Demesne, the park of Huntroyde, is particularly extensive and much of the surrounding area was used for shooting. Law Farm, left, is just outside the Demesne (the property to the right of the wall, left, in the picture) which, in the past, referred to the land not let out to tenants. This land contained formal gardens and woodland for the pleasure of the landowner and his family, and fishponds and a walled garden that provided food for the table. We have come across fish ponds before, when we were looking at Whalley. Here there were at least three ponds that supplied trout and carp in the days before refrigeration when transporting fish from the sea was difficult.

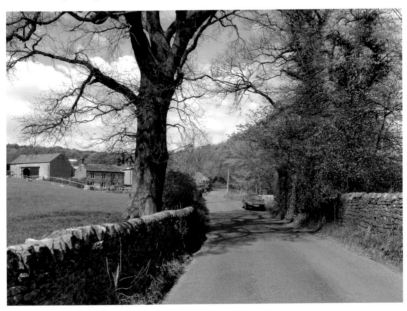

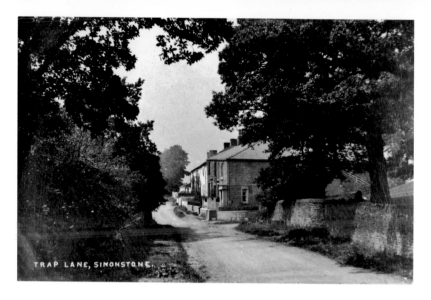

TRAP LANE, SIMONSTONE.

Trapp Lane, Simonstone II

A walk along the quiet Trapp Lane is one of the simple pleasures open to those who live in this part of the world, and the beauty of it is that the walk gets better the more it is undertaken. The walk takes one through Simonstone village, by St Peter's church, Simonstone Hall, Huntroyde Demesne, a number of other interesting buildings and out into the countryside. The lane gradually rises passing the Higher Trapp Hotel on the left, but, on the way, the walker comes to the tree-lined crossroads shown in these images. There is nothing spectacular about Whins Lane or its buildings. They are a charming mixture of cottages, farmhouses and barns from different periods but, depending where you care to walk, this little tour has some interesting names. What about Cockshutt's, The Cavaliers, Priddy Bank and the Higher Trapp itself? Considering these pictures, one of the authors of this book misses the little shop that used to be run in the first property in the row and he is not so sure about the Activity Centre lower down the lane.

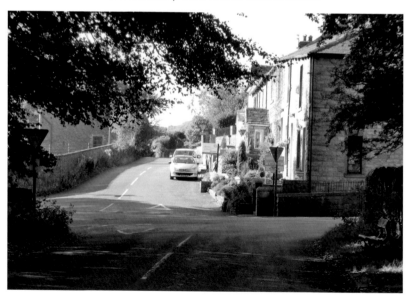

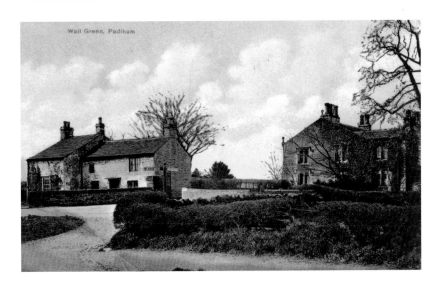

Wall Green, Near Padiham

This interesting group of buildings, at the junction of lanes, is on Huntroyde land to the north of Padiham. The lane to the south is the continuation of Padiham's Slade Lane. The one to the west passes round the north of Huntroyde Demesne on its way to Whins Lane, mentioned above. A lane heading north takes the walker past the Red Rock and The Cavaliers to Padiham Heights. It was on the narrow lane that runs west to east on the Heights, which overlooks the Sabden Valley, that the sport of road walking was developed in the early nineteenth century. The sport was enhanced by large amounts of money placed on different walkers. Challenge matches between champion walkers were not uncommon and men from all over the area got themselves involved, if not as walkers then in the betting that took place. Of course there were crowds of men at big events and, sometimes, the races were reported in the local press. It might be difficult to believe but there was once a small shop at Wall Green. This was in the days before the turnpike road lower down the valley was constructed and, consequently, there were more travellers, some of whom would have been on their way to the Old Corn Mill at Read.

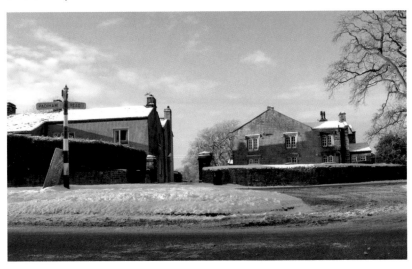

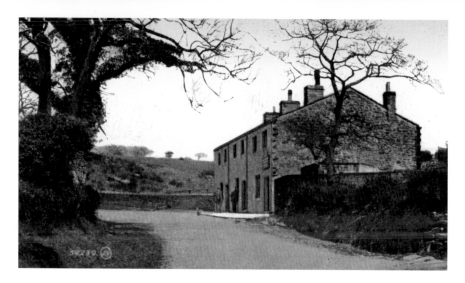

The Red Rock

The Red Rock was a lovely country inn until quite recently. Originally, it was a short row of weavers' and labourers cottages the end one of which was a beer house. If you look carefully at the old image you will see that there is a sign over the first of the doorways. This tells the traveller that refreshments – beer brewed on the premises – were to be had and lots of them would have availed themselves of the information. In those days the road to the left of the Red Rock was quite busy with horse-drawn traffic to and from Sabden. There was a living to be had by brewing your own ale and selling it to passersby. Of course this had to be combined with other activities, but it was a living. In more recent times the Red Rock acquired a good reputation for its catering but, like many country inns, it had to close. Today the whole of the property is one house.

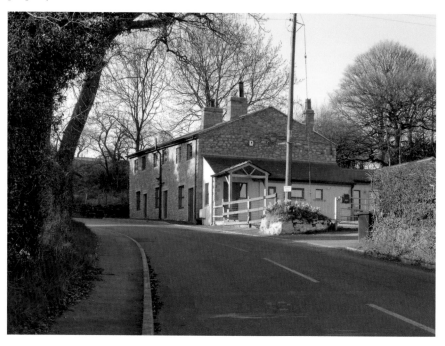

The Village of Sabden

Sabden, and its beautiful valley, is said to be 'one of Lancashire's hidden treasures' and few of those who know them would argue with that. However, there was a time when the word Sabden was used for a number of local places but not the village. There was the Sabden Valley, the Sabden Beck, Sabden Bridge and Sabden Hey. The latter is the nearest name to that of the village; however, it did not refer to Sabden, as we now know it, but to a small part of it that was also known as Heyhouses. In the past there was no such place as Sabden as it was created in 1904, taking bits from Pendleton, Read, Wiswell, Northtown, Higham, Goldshaw and the whole of Heyhouses and moulding them into a new parish. This composite postcard shows the parish church of St Nicholas, which was opened in 1841 (centre). On the left, top, is what is called the Council School on the postcard. The school was, in fact, founded in 1836 as 'the British School' by Richard Cobden, one of the leaders of the Anti Corn Law League and the person after whom the Cobden Treaty is named. The lower photograph, left, is an image of the Clitheroe road, the one that climbs the Nick of Pendle. On the right the top photograph is a view of the village from Padiham Heights. Below is the Wesleyan Chapel of 1879.

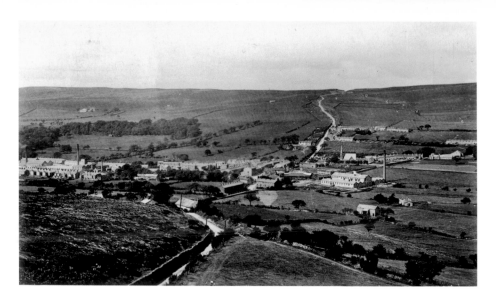

Sabden from Padiham Heights

The older of these images is a fine view of the village. The original Heyhouses is off the picture to the right as is St Nicholas' parish church and its school. The spire, to the right of centre, is that of the Wesleyan Chapel. The photograph also gives some idea of the distribution in the village of the industrial buildings which were, in the main, a mixture of calico printing works and cotton mills. In the background you can see the Clitheroe Road leading up to the Nick o' Pendle. This can be seen right at the top of what is quite a steep hill. The Nick o' Pendle is a favourite place to start the ascent of the famous hill. It is a really stiff walk to get to the top but the walk is an easier one than climbing to the summit from Barley, several miles to the east. At the top, and on a good day, there are splendid views to be had and it was from this vantage point that George Fox had a vision which inspired him to found the Society of Friends, otherwise known as the Quakers. In the foreground you can see the road that leads over Padiham Heights to the Red Rock and Padiham, but the little road to Higham is not visible.

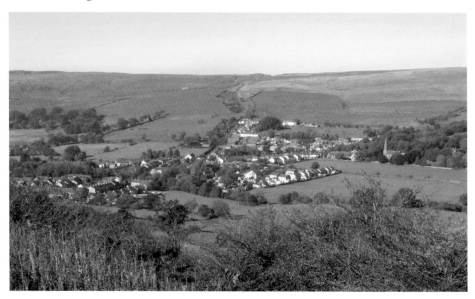

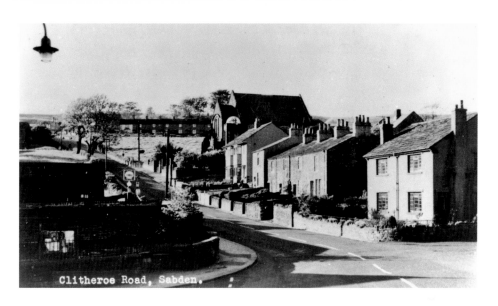

Clitheroe Road, Sabden.

The Clitheroe Road, Sabden

These pictures do not give an accurate representation of the climb out of Sabden towards Clitheroe. It was a difficult one in the age of horse-drawn vehicles and it remained so in the early days of motoring. The older photograph shows the lower part of the road not all that long ago because the garage at the bottom of the hill is in business. At the Whalley Road junction there is one of the village schools, but on the Clitheroe Road you can see the cottages above what is now Wesley Street. The large building partway up the hill and to the right of it is the Baptist Chapel of 1910 and, in the background is one of the several rows of cottages accessed from Clitheroe Road. These rows include Bury's Row – named after the Bury family who were involved in the local calico printing industry – Crow Trees Row, Top Row and Step Row. Not all of these names are used these days but they appear on the six inch to the mile Ordnance Survey map of the 1840s.

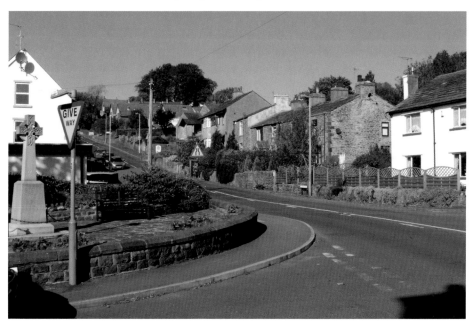

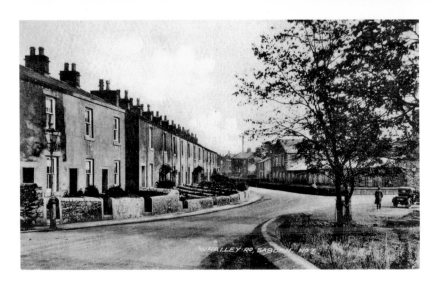

The Whalley Road, Sabden I

The road to Sabden from Whalley is one of the most the most pleasant drives in the district. It takes the car close to the Spring Wood nature Trail, around the eastern end of Whalley Golf Course, Portfield (the site of an ancient hill fort and later of the now-demolished Portfield Hall) along much of the length of the Sabden Brook, to The Whins, a sizeable house in the village, and on to Sabden itself. There are also views to be had towards Wiswell Moor, to the left, and towards Read and Simonstone, to the right. A detour near Portfield would take the driver to Read Old Bridge, which was a favourite spot for the Lancashire author, the late Jessica Lofthouse. Perhaps her best book is *Three Rivers*, which tells the story of the Ribble, the Hodder and the Calder. In her study of the latter she tells the story of Sabden Brook and connects it, and Old Bridge, to the story of the great angler, Alexander Nowell, the Elizabethan Dean of St Pauls and the inventor of bottled beer. Alexander came from the family that owned the Read estate, which included parts of the Sabden Brook. The brook also saw a Civil War battle and it was the site of Read Old Mill.

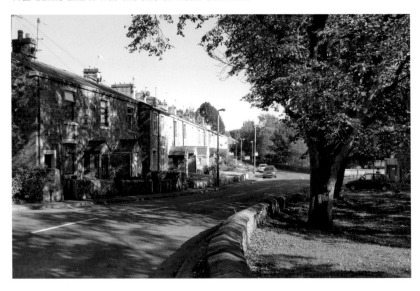

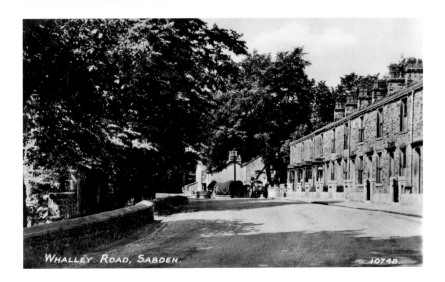

WHALLEY ROAD, SABDEN. 10748.

The Whalley Road, Sabden II

This old photograph is of a small section of Whalley Road in Sabden. There are now quite a number of rows of houses on the road. Each row is different but the best row is Dial Row, which takes its name from the splendid sun dial above the house in the middle. The dial cost all of 4s and 2d (21p in modern money) when the houses were built in 1837 – the same year the Queen Victoria came to the throne. Working people rented their homes in the early days of industrialisation but the firm of Cobden, Sherriff, Foster & Co., who were calico printers in the village, set up a scheme to enable some of their workers to purchase houses built by the firm using the usual rents paid. A small premium was added which covered the firm's costs. The scheme was very successful and may account for the fact that quite some of the housing in Sabden is better than similar property elsewhere. As you can see these are the stone-built terraced properties that can be found in most of the Lancashire mill towns and villages but these, and Dial Row, are a bit special.

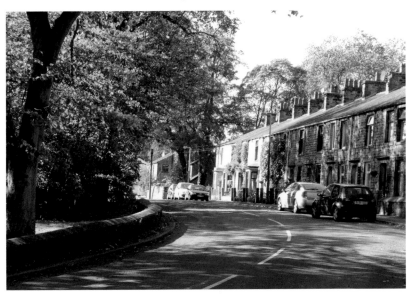

SABDEN RESERVOIR. 10749.

Sabden's Water Supply

Many of the more rural communities in the Lancashire Pennines had to wait some time before they got piped water, even if larger towns obtained permission to take water from their township. This happened in Briercliffe and Worsthorne, near Burnley, where first private companies, and, later, municipal undertakings, took water to Burnley itself but left Briercliffe, for instance, without piped water until just before the First World War. This did not happen in Sabden because the village has had its own piped water from 1861. In that year the Fort family built a small reservoir below Brogden Farm for the village, a great boon to everyone fortunate enough to be connected. Elsewhere, people in villages off the beaten track (one of the charms of Sabden) had to go to the village well and carry their drinking and bathing water home. It is no wonder that the Brits got something of a reputation for not washing as often as they might have done. In 1892, Churn Clough reservoir, which is north of the old road between Heyhouses and Sabden Fold, was opened to supply fresh water to Padiham and Hapton.

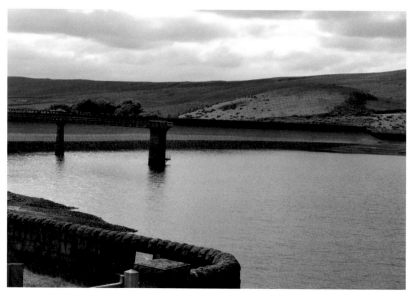

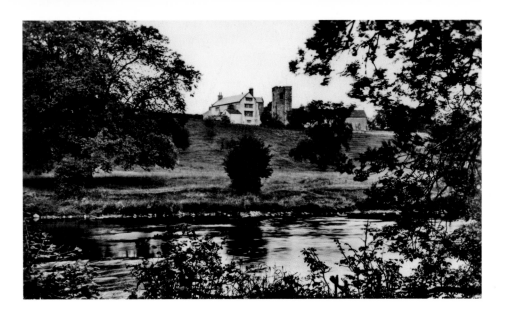

Great Mitton Hall and All Hallows Parish Church

The village of Great Mitton is divided from its near neighbour, Little Mitton, by the swiftly flowing waters of the River Ribble. The river once marked the county boundary with Little Mitton, on the left bank of the river, in Lancashire, and Great Mitton in Yorkshire. Even today, though the two villages are in the same Borough, they are in different diocese with Great Mitton in Bradford and Little Mitton in Blackburn. This picture shows the most historic parts of Great Mitton from the Lancashire side of the river. On the left is the fourteenth-century Great Mitton Hall with the parish church of All Hallows, which is first mentioned in 1103, on the right. Just off the picture is Mitton Bridge, which dates from the early years of the nineteenth century. Before that, and until 1810, the famous ferry was still in use and the inn on the Little Mitton side of the river, now known as the Aspinall Arms, was spoken of by local residents as the 'Mitton Boat'. Mitton, the place name, derives from the Old English meaning 'the farm at the junction of two rivers' – in this case the Ribble and the Hodder.

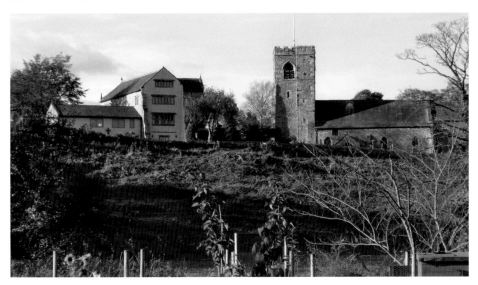

All Hallows Parish Church

Though only a few miles from Whalley, the parish church of Great Mitton is unlike other churches in the area in that it has little with Whalley. All Hallows is the mother church of a number of parishes, which include Waddington, Grindleton, West Bradford and Hurst Green. The present building dates from the latter thirteenth century and is dedicated to All Hallows though the original dedication was to St Michael and All Angels, as is depicted in the east window. The oldest part of the church is the unusual nave, which descends towards the chancel of 1295. This can be seen in the photograph – the west tower of the fifteenth century was attached to the existing nave, which itself was extended by the addition of the chancel on the right of the images. A visit to All Hallows is a must for all those of you who are interested in medieval churches – and not only because of the building but also for what it contains.

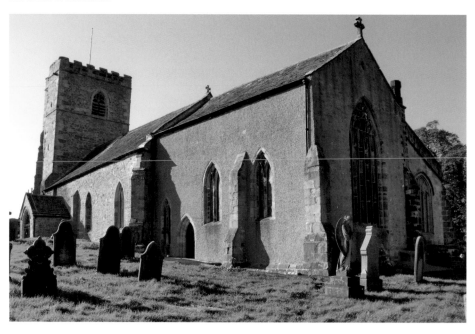

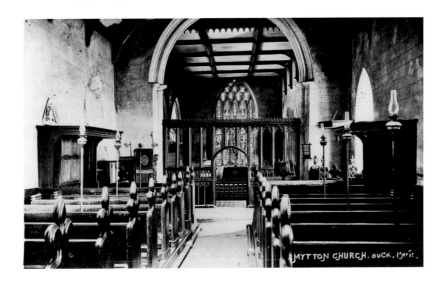

All Hallows, Interior

J. M. W. Turner visited the church in 1799 when undertaking a commission for Dr
T. D. Whitaker, later the vicar of Whalley, whose great book on the original parish
of Whalley was under preparation at that time. The result of Turner's visit was a
drawing of the interior of All Hallows, which is still of great interest. The church
itself does have something in common with St Mary and All Saints in Whalley in
that both churches contain monastic remains. In the case of Great Mitton the lovely
fifteenth-century chancel screen, which is made of wood and cast iron, probably
came from nearby Sawley Abbey, though Dr Whitaker thought that Cockersand,
in north-west Lancashire, was more likely. Some observers have claimed that the
chancel contains an unusual curiosity, a small leper's window of around 1325.
However, even though the window contains later references to the disease, this is
unlikely as there are no records and the local leper hospital, which existed in the
Middle Ages, had connections to Whalley and Clitheroe but not to Great Mitton.

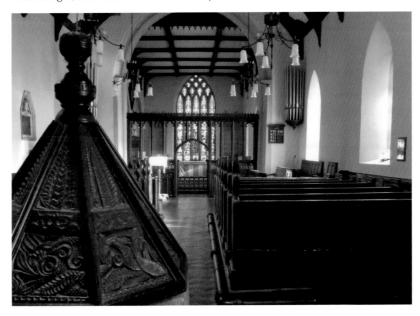

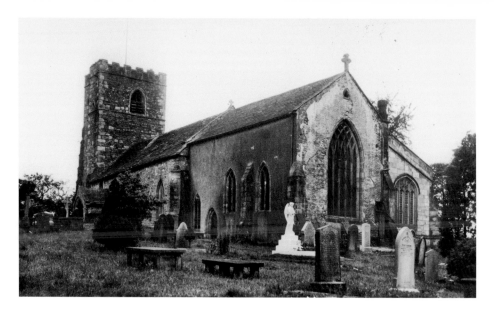

The Churchyard, All Hallows, Great Mitton

The churchyard at Great Mitton is almost as interesting – especially for its memorials – as the church itself. Perhaps the best-known artefact is the fourteenth-century cross head, which was found in the churchyard in around 1801. It is mounted on a new column but that it has survived is something of a miracle. On the north side of the cross there is a Calvary Scene, on the other, a crucifix figure. There is also a sundial of 1683. Near the tower there is a stone coffin that came from Little Mitton Hall, on the other side of the river, where it had been used as a water trough. The view up stream from the churchyard wall is a splendid riverscape, but note that the old road from the ferry into Great Mitton can still be identified in the plot of land called Moses, or Mowses, between the churchyard wall and the river. Once on the right bank of the Ribble the village was accessed from a lane that passed to the east of the church. It was near here, in 1793, that four houses, two barns and much other property were consumed in a great fire started by a boy sweeping a chimney.

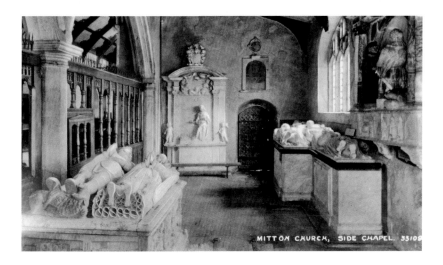

MITTON CHURCH, SIDE CHAPEL. 35109

The Shireburne Chapel

Many of the visitors to All Hallows come to see the Shireburne chapel, which dates from around 1440. The chapel, which contains many splendid family memorials, was founded by the Shireburne's of Stoneyhurst. They were an eminent Lancashire family which had considerable interests in Yorkshire and the Isle of Man. The oldest monument is to Sir Richard Shireburne (*d.* 1594) who was Master Forester of Bowland, Steward of Slaidburne, Lieutenant of the Isle of Man and Deputy Lieutenant for the County of Lancaster. It was Sir Richard who rebuilt the chapel. His son is depicted, on the wall opposite, kneeling at a prayer desk facing his wife. This monument contains carved alabaster panels showing their children. Other monuments refer to the Woodruffs of Bank Top, Burnley, the Towneleys of Royle (also Burnley), and the Dukes of Norfolk, but the most interesting of the monuments is that to a boy of only nine. The memorial is to Richard Shireburne, who died of eating poisonous berries, and it is of a type known as an 'angel in marble' monument. The young boy, who died in 1702, is shown surrounded by tearful cherubic figures, the 'angels in marble' – a term which British sephologists use to indicate working class support for the Conservative Party

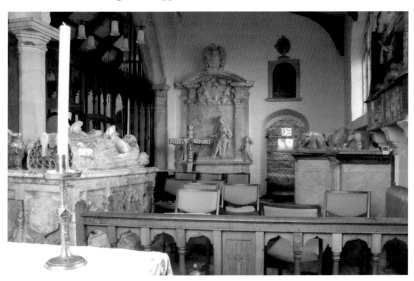

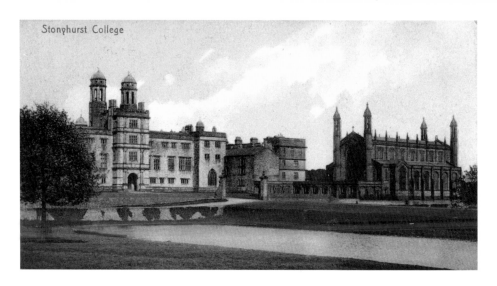

Stonyhurst College

Stoneyhurst

Stoneyhurst was the home of the Shireburne family for 400 years, though it is now a famous public school. It was in 1794 that Cardinal Thomas Weld (the Welds had succeeded to the estate earlier in the eighteenth century) who offered the house to the Jesuits. They were expelled from France at the time of the Revolution but the Order had run a school for the sons of Catholic Englishmen at St Omers since the sixteenth century. Stoneyhurst was, initially, intended as a temporary harbour for the Jesuits and their pupils but they have been there ever since. A number of well-known people have had connections with Stoneyhurst and these include Sir Arthur Conan Doyle, the author, Gerard Manley Hopkins, the poet, and J. R. R. Tolkien, the writer of the *Lord of the Rings* trilogy. Tolkien used to take walks in the Stoneyhurst area with his son, who was a pupil at the school, and these walks inspired aspects of his novels. In less peaceful times Oliver Cromwell visited Stoneyhurst when it was still the home of the Shireburnes. This was in 1648 when Cromwell is supposed to have crossed the bridge, which bears his name, and stayed overnight, sleeping on a table, with guns at his side for fear of assassination in a Catholic household.

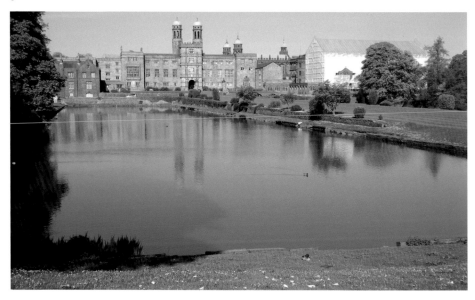

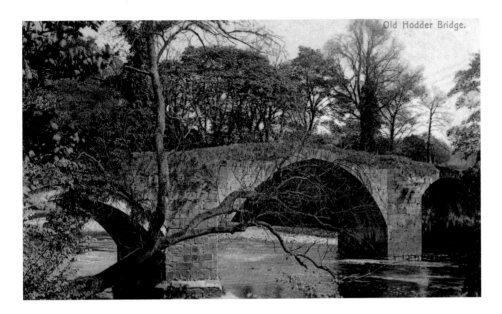

Cromwell's Bridge at Lower Hodder

This is the bridge commonly known as Cromwell's Bridge. The name refers the story that, in 1648, Cromwell's Parliamentary army crossed the bridge before the man who was to be Lord Protector headed for nearby Stoneyhurst where he slept before he engaged the Royalists at the battle of Preston. However, it is not certain that this bridge was the one used by Cromwell and his army. He certainly crossed the Hodder but it could have been at another nearby bridge that has since been demolished. The history of the bridges at Lower Hodder is complicated, because, even today, there are two bridges very close together. What can be said is that there was a bridge here in the early fourteenth century and doubtless before. A new bridge was built in 1563 at the expense of Sir Richard Shireburne who also provided the stone. It is also worth commenting that the Jesuit's of Stoneyhurst were involved in hiring the great road engineer Thomas Macadam to rebuild the road from Lower Hodder to Hurst Green. It was he who designed the present road bearing Lower Hodder Bridge.

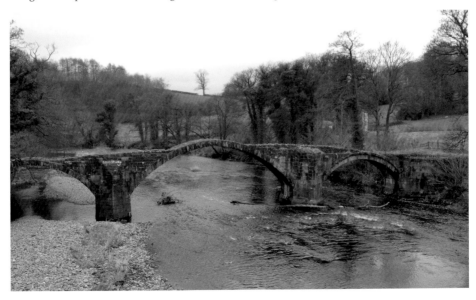

The Former Higher Hodder Hotel

The River Hodder is one of the most beautiful in England though it is not as well known as it should be. It is only two miles between the Lower and Higher Hodder Bridges but the walk is lovely and, after emerging from woodland, those who take this route find themselves in a little glen marked by a number of cottages all sheltering under the dominant Higher Hodder Bridge. A frequent visitor was Jessica Lofthouse whose book, *Three Rivers: Being an account of many wanderings in the dales of Ribble, Hodder and Calder*, published in 1946, is still worth the read today. Her joy in this part of the world can be seen in the following: 'To-day's particular beauty has been in old buildings rising out of apple orchards, and the scent of apple blossom. Higher Hodder Bridge is mantled with ivy-leaved toadflax, a pale mauve cloak, in and out of which busy birds are constantly passing, feeding nestlings in the crannies of the stones.' The hotel has been closed for some years and the large building has been converted into a number of very desirable houses almost all of which enjoy wonderful views of the surrounding countryside,

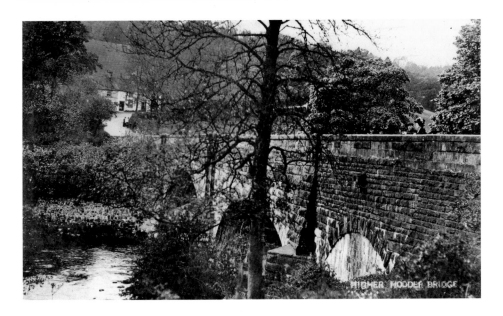

The Higher Hodder Bridge

The bridge has a good span and stands high above the waters of the Hodder. Seen from Birdie Brow, the bridge is the centre of interest of one of the happiest pictures in the dale. This is Jessica Lofthouse's opinion and who would disagree with her? The Higher Hodder Bridge gives access to a little wonderland and Jessica, on a visit to the area, writes, 'I must be the first comer. No one has broken the barricades of spiders' webs for me. Birds are still about their morning's toilet. A blackbird is giving himself a shower and preening on the brink; a dipper bobs at his reflection; a heron stands poised on a boulder, and everywhere are trotting wagtails, grey and black against grey and white pebbles. Wood doves are crooning deep in the wood, scores of warblers are in song, more thrushes and one valiant little robin which, alone, refuses to be worsted by all these May-time songsters. He is the gayest challenge to the morning. How I love these woods, the secret places and the new clearings open to sun and sky.'

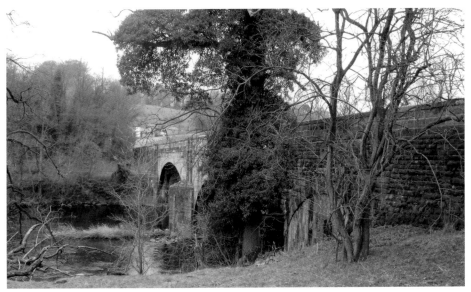

The River Hodder

The whole of the valley of the Hodder can be seen on sheet 103 of the OS Landranger map. The river commences its journey to join the Ribble near Lamb Hill Fell above Stocks Reservoir through which it passes on its way to Slaidburn. Here the Croasdale Brook joins the Hodder and the much-enlarged river passes Dunnow, Easington and Newton to Dunsop Bridge where the Dunsop and Langden Brook also join. From there the river flows, through beautiful countryside, in the direction of Whitewell and on to the Doeford Bridge where the Hodder is joined by the Loud. This is now Little Bowland and, just below the Doeford Bridge, the Hodder crosses the line of the Roman road to Hornby, parts of which can still be identified. From here the character of the river changes a little and when it gets to the area of the Hodder Bridges a number of pools, superficially ideal for swimming, are encountered. However, Jessica Lofthouse warns that, 'All the inviting pools in the Hodder are not safe swimming There are dangerous whirlpools and treacherous currents, and there have been many cases of drowning.' Eventually, the river reaches Great Mitton and, just below the village, and close to Winckley Hall, and its park, it joins the Ribble.

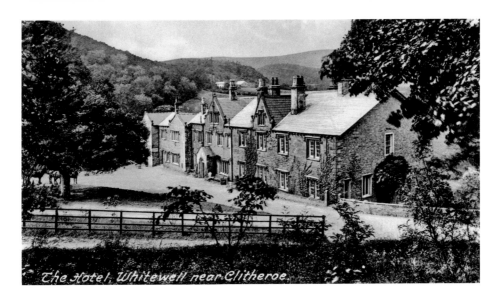

The Hotel, Whitewell near Clitheroe.

The Inn at Whitewell I

The Inn at Whitewell is now part of the estate of the Duchy of Lancaster. The reigning monarch, whether male or female, since 1399 when Henry IV deposed Richard II, has always been Duke of Lancaster. The Loyal Toast, for Lancastrians, is a source of considerable pride as the words are, 'The Queen, the Duke of Lancaster'. The present building is a much enlarged version of a much older building which was once known as Whitewell Manor and it was here that Manorial and Forest meetings and courts were held. In Dr Whitaker's history of Whalley there is a fine engraving of Whitewell as it was at the end of the eighteenth century. The inn is termed a 'Keeper's Lodge', in this illustration, but it has provided refreshments for travellers from Lancaster to Blackburn or Whalley for centuries. Later, as Jessica Lofthouse observes, the inn was taken over by the anglers who fished the waters of the nearby Hodder. She laments that the inn is not the place that it once was but now the inn is one of the most welcoming places in the Hodder valley.

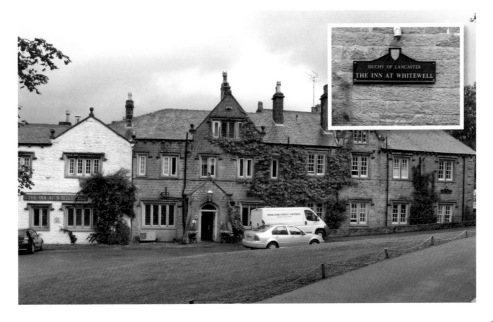

Whitewell.

The Inn at Whitewell II

These photographs show the proximity of the inn to the River Hodder. Here the river flows at a languid pace, ideal for fishing, though it is no more than sixty-five years ago that otters were hunted hereabouts. Before that it was the deer that was hunted and this area has a history of the hunt as long as any in the country. The inn is a large building and, once inside, the views of the surrounding countryside are wonderful. The diner can sit near a window and watch grouse amble close to the building almost begging to join the next game pie. Rabbits seem to have the same propensities. Of course the inn at Whitewell is a great place to base a walking holiday or for visiting the Forest of Bowland, which is an area of outstanding natural beauty. The forest, in royal ownership and that of the Duke of Westminster, has hardly changed in recent years. The estates are managed for wildlife though the area is not without farms. 'Development' is not really permitted.

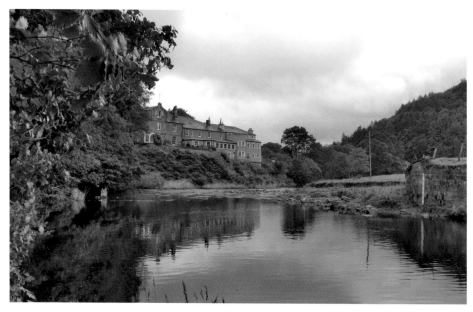

The Hipping Stones, Whitewell

This picture shows the stepping stones close to the Inn at Whitewell. Known locally as 'Hipping Stones', these were used as a way of quickly crossing the river before the small footbridge (seen in the previous old picture of Whitewell) was constructed. A good sense of balance and a little bit of courage is needed to cross the river here but the effort is well worth it as there are many great walks to be experienced in this area. Not far from the 'Hipping Stones' are the enchanting 'Fairy Holes', a handful of small caves in the limestone crags. During a 1946 excavation of these caves evidence of Bronze Age life were found including a collared urn, the only one of its type to have been found in a cave in Lancashire. Jessica Lofthouse wrote of the Fairy Holes: 'everyone knew that these little caves in the limestone at Whitewell were the homes of the little folk.'

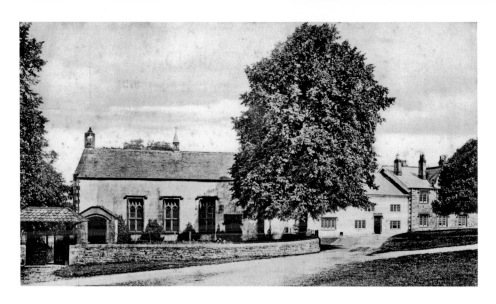

St Michael's Church, Whitewell

The small church at Whitewell can trace its origins to one Walter Urswick who lived in what is now the inn in the middle of the fourteenth century. There he established a small chapel where he and his family, and other foresters, could come together for religious purposes. Little is known about the building in those early days though the building was much smaller than the present church and it was thatched. Changes were made in 1422 but, at the time of the Reformation, the chapel dedicated to St Michael the Archangel, which had been established by Robert de Lacy in Clitheroe Castle, was abandoned and the endowment and dedication transferred to the chapel at Whitewell. In 1817 the chapel was rebuilt and enlarged. By 1878 Whitwell became a parish and its connections with Clitheroe were severed. The church is well worth a visit and we would recommend that you consult Jessica Lofhouse for her description of the building in the inter-war years.

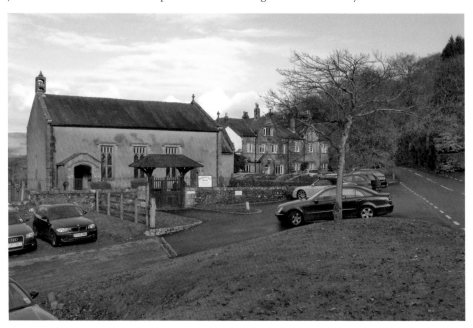

St Hubert's Catholic Church, Dunsop Bridge

Very few Roman Catholic churches, in this country, can claim the history that is enjoyed by this church. Opened in May 1865 by Bishop Richard Roskell of Nottingham, the church of St Hubert, the patron saint of hunting, it is said was paid for out of the winnings from a horse race. That race was the 1861 Epsom Derby and the winner was a horse called Kettledrum which was owned by Col. Charles Towneley of Towneley in Burnley. The Towneley's had a stud at Root Farm in Dunsop Bridge where the colonel's younger brother Col. John Towneley had a house, Thorneyholme. The church, which was served by the Jesuits at Stoneyhurst, was designed by Edward Welby Pugin in a style that could only be Catholic and of the mid-nineteenth century. There are a number of interesting features in the church. The east and west windows are by Capronnier of Brussels and they were completed in the year in which the church was opened. A medieval font came from the ancient chapel at Whitewell. St Hubert, in one of the windows, is shown as a huntsman with a stag, an apposite image because the church is within the Royal Forest of Bowland. There is also a memorial to Richard Towneley who, had he lived, would have succeeded his father to the Towneley estates.

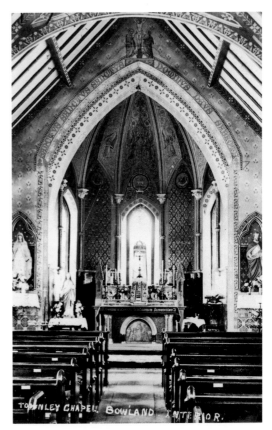

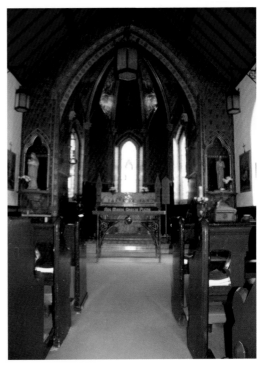

Townley Chapel Bowland

St Hubert's Church, Dunsop Bridge

The village of Dunsop Bridge is one of two main contenders to be the exact geographic centre of Great Britain. The other is Haltwhistle in the north-east of England and though this argument might not have been settled there is no doubting that Dunsop Bridge is in a beautiful location. The village is on the Royal Duchy of Lancaster estate and HM The Queen is said to be very fond of the area. In fact, asked rather cheekily, that if she had to abdicate where would she choose to retire? The Queen, quick as a flash, replied 'Dunsop Bridge and the Forest of Bowland!' The Towneley family owned Bowland from 1835 and it was from about this time that the village began to grow, not only because of the breeding of horses, which was carried on there, but because of the opening up of a number of lead mines in the area. These photographs show the apsidal end of St Hubert's and the last resting place of Col. John Towneley, his wife and the son, who preceded him. Their graves are marked by a stately white marble angel and this statue recalls Col. John's daughter who inherited this part of the Towney estate. She was Mary Elizabeth Towneley, otherwise known as Sister Marie des Saints Anges, the Provincial of the English Province of the Sisters of Notre Dame of Namur.

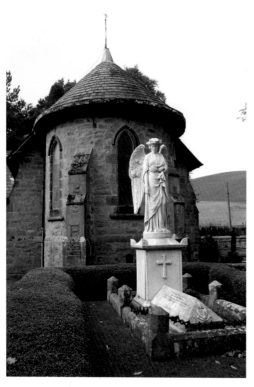